FACT, the Foundation for Art & C̲r̲e̲a̲t̲i̲v̲e̲ ̲T̲e̲c̲h̲n̲o̲l̲o̲g̲y, is the UK's leading organisation for the commission, presentation and support of artists' work in moving image and new media art. International as well as UK-based artists exhibit, produce and develop their practice with FACT.

Furtherfield.org provides platforms for creating, viewing, discussing and learning about experimental practices at the intersections of art, technology and social change. It believes that through creative and critical engagement with practices in art and technology people are inspired and enabled to become active co-creators of their cultures and societies. HTTP, Furtherfield.org's gallery in North London, is a dedicated space for media art.

colophon

First published 2010 by

FACT (Foundation for Art and Creative Technology)
88 Wood Street
Liverpool L1 4DQ
www.fact.co.uk

Distributed by
Liverpool University Press
4 Cambridge Street
Liverpool L69 7ZU
www.liverpool-unipress.co.uk

Customers in the USA, Canada and Mexico
should purchase from University of Chicago Press
at www.press.uchicago.edu

Copyright © 2010 FACT (Foundation for Art and
Creative Technology)

British Library Cataloguing-in-Publication data
A British Library CIP record is available

ISBN 978-1-84631-247-2

Edited by Ruth Catlow, Marc Garrett and
Corrado Morgana
Design by www.axisgraphicdesign.co.uk
Printed and bound by DeckersSnoeck, Belgium

FACT is a registered charity No. 702781. Company
limited by guarantee Registration No. 2391543.

HOUSE OF TECHNOLOGICALLY
TERMED PRAXIS

LOTTERY FUNDED

front cover detail and back cover
Kriegspeil, RSG, 2008

FOUNDATION FOR ART AND
CREATIVE TECHNOLOGY

Contents

Artists
Re:thinking Games

Preface
Mike Stubbs
Director/CEO, FACT, Liverpool

The proliferation of screen based technologies has seen a move from the shared public viewing experiences of cinema, through to the TV period (perfect for nuclear family home viewing), to the most recent explosion of private experiences on a variety of powerful shrinking screens. Portable game consoles, phones and PCs dominate our experience of the world, seeming to close the circle of public to private experience... that is, until we take networks and connectivity into account, on the rise in game environments as elsewhere.

Artists Re:thinking Games accompanies Space Invaders, an exhibition at FACT which presents artists who have been fascinated by the materials and contexts of games and game play, and in turn beg of us, the audience, to think more deeply about how we experience the world. As technologies, interest groups and communities converge further, we move beyond simulation to realize the exquisite opportunities within a paradigm of mixed realities. This is tantalising to work within and de-construct, especially to younger artists, brought up with games as one of the strongest parts of their culture.

I would like to take this opportunity to thank Ruth Catlow, Marc Garrett, Corrado Morgana and all at Furtherfield.org for co-publishing this book with FACT.

Introduction
Artists Re:thinking Games
Corrado Morgana

INTRODUCTORY CUTSCENE

Digital games are important. Not only because of their cultural ubiquity and their enormous sales figures but for what they offer as a space for creative practice, significant both to the game designer and to the artist that "thinks" games. Re-appropriated for activism, activation, commentary and critique within games and wider culture, artists have engaged in adventurous and critical discourse using the engines and culture of games as tools and material. Over the last decade communities of practitioners have grown up, producing and disseminating engaged work both online and offline. This has been gathered together in ambitious art exhibitions around the world, which have achieved that rare combination of criticality and popular appeal. Gallery and other exhibition models have presented commercial games next to independent games, Artgames and Game Art (more on these terms later). Significant curatorial engagements have ranged from from Anne-Marie Schleiner's seminal *Cracking the Maze* (1996) and the historical arcade of the Barbican's travelling exhibition *Game On* (2002), to Laboral's exhibition trilogy, which included *Gameworld* (2007), *Playware* (2007) and *Homo Ludens Ludens* (2008), and concurrently, Furtherfield. org's Game Art programme.

This publication looks at how a selection of leading artists, designers and commentators engage with the premise of artists rethinking games, in a creative practice that challenges the normative and expected. It draws philosophical parallels with Situationist strategies and hacker mentalities common to disruptive and tactical art. The uprooting and subverting notion of détournement is a theme that is common to our own collected practices and motivations. With an upswell of activity within both the media arts (which has historically been linked with playful praxis) and independent games design communities, the time is right to acknowledge these practical commonalities. This text will attempt to provide an overview of some of the themes adopted by artists that think and also rethink games.

CHARACTER CREATION

The Situationist term *détournement* describes an overturning of the established order; an unforeseen activity within the institution, utilising its tools and imagery that overthrows conventions to create new meaning by appropriating and juxtaposing. Détournement is also central to hacker culture; taking "stuff" and making that "stuff" do things it wasn't meant to

do. By modding, hacking, exploiting and other strategies of intervention, artists, game designers and players have responded to preset game limits and other practical and creative boundaries. They have responded by producing artefacts and activity that re-appropriate dominant culture, where normative tropes and memes are subverted and détourned to produce a counter to expected "normal" behaviour. McKenzie Wark's *Hacker Manifesto* (2004) develops Stephen Levy's (1984) hacker ethic. Levy promotes a sharing and openness of information and tools but also a mistrust of authority, promoting decentralization. Wark develops this into a mentality that chooses to challenge conventional knowledge and behaviour. Wark refers to factors which steer convention and behaviour as "vectoral." These vectors, such as property, information and capital, are steered by "vectoralists" who would guide behaviour for economic gain or other institutional control by fostering predictable behaviour. The artist that thinks games questions, juxtaposes, reinvents and challenges these vectors.

Commercially produced digital games have for some time fostered user-produced content to enhance the longevity of a product. Given a set of tools by commercial and enthusiast developers, the community of gamers and artists enthusiastically generate content. Produced via software development kits, level editors, and gameplay recording tools, and disseminated through sophisticated distribution networks, artefacts such as in-game objects, outfits, creatures, levels and machinima can be swapped, sold and otherwise distributed within an enthusiast/gamers' habitué.

This form of normative practice, fostered by the developers, is mostly expected and accounted for; protests against Digital Rights Management by users of the game Spore, where users develop their own organisms and societies, are a relatively recent notable exception. Players, irate at EA's restrictive DRM implementation which only allowed 3 activations (consecutive installations) of the game, protested by creating and disseminating, through the Sporepedia, an official online repository of user generated content, creations with slogans like "fuck DRM" and "DRM suxx." This protest eventually convinced EA to relax restrictions.

Things are "normative" when they are operating "normally," according to convention or ideology, but in who's eyes? The putative mainstream, its expectations and institutions? If art is to challenge the normative or vectored, then non-normative praxis must be explored: non-normative performativity, as in Joseph DeLlappe's *dead-in-iraq* (2006-ongoing) project, an intervention in the multiplayer first person

shooter *America's Army*, a US Army recruiting tool. DeLappe types the names of dead US soldiers into the game's chat function, disrupting normal game flow. Or non-normative design where software development kits, level editors and ground-up production techniques generate artefacts that challenge and question mainstream tropes, rather than reinforce them. We can also count gameplayers who challenge prescribed behaviour, cheating and exploiting in-game bugs and level codes. The discovery and dissemination of such strategies, whether for the purpose of game advancement or free-er play, sets up communities that thrive on countering expected behaviour.

Regarding in-game performativity, Anne-Marie Schleiner has discussed Situationist play strategies within gamespace, directly relating Situationist playful praxis to interventionist activity and modding. Wark (2007) describes gamespace as all pervasive, extending beyond the game itself with associated cultural and social implications. Schleiner (2008) issues a call to arms to game designers, hackers, modders artists and players:

> We are bored with the suburbs, the stale imperialist sexist engineering biased corporate game industry, and with new academic ludology that reifies existing superstructures. We are ready to play reality TV off camera. We are frustrated with our governments and the military superstructures that control gamespace. We don't want to play by rules we never agreed upon in the first place. Anyways, even if we had fun playing those games to begin with, it is now more entertaining to mess them up, or to invent new unsanctioned games inside gamespace. If big players are intervening in gamespace, then it is time for Situationist gaming.

With this rallying call in mind and without unintentionally denigrating the artform of games design, what is under discussion? Are artists producing games and activity within games or are games developers producing art? Two terms have emerged: Artgames and Game Art.

ARTGAMES, GAME ART: FIGHT!
An Artgame is an independent or commercial game which expresses its "artness" through its play mechanics, narrative strategies or visual

language. An Artgame may employ novel interfaces, non-mainstream narratives, retro visual language, experimental gameplay and other strategies. An Artgame may be any interactive experience that draws on game tropes. Artgames are rapidly détourning mainstream game expectations, although whether designers specifically use the term whilst producing transgressive and novel independent games is a moot point. Daemon Hatfield (2009), writing for IGN, describes entrants in the Independent Games Festival as "the art house films of the game industry, developed on shoestring budgets but crafted with love and personality." Games free from commercial constraints innovate, experiment and play with genre and media.

I'll list a few recent works, which help define the arena and illustrate some of the issues with terms and definitions; definitions which are mutable, tenuous and sometimes inappropriate and contain categories within categories. These examples may or may not be intended as Artgames but are significantly critical.

A parodic game like *Progress Quest* (2004) questions similar issues by removing the gameplay. *Progress Quest* is a self playing Role Playing Game with the visual language of an Excel spreadsheet. *Progress Quest* was featured in Furtherfield.org's 2007 exhibition at HTTP Gallery and the London Games Festival Fringe, *Zero Gamer*, which examined self playing games and the spectatorship of gameplay and game culture. An ironic take on the role of the player, *Progress Quest* removes the player entirely from the equation. Other than initial character setup, the game plays entirely without user input, a wry swipe at the continuous grinding of role playing games – a conceptual joke, that removes the all important play element. Similarly other metagames, games about games and gaming, such as jmbt02's *Achievement Unlocked* (2009) and *This is the only level* (2009) also question the nature of specific game mechanics, player reward and play culture through gameplay.

Novel interfaces are explored by Jetro Lauha's *Racing Pitch* (2007), a microphone-controlled toy car racing game in which the gamer controls the car by making car noises, and by Ratloop's *Mightier* (2009), where users solve puzzles by physically drawing solutions on paper and scanning them into the game via webcam. Activist works with an irreverent sense of humour like those by Molleindustria (which they themselves describe as "Radical games against the dictatorship of entertainment") and Mary Flanagan's serious games such as *Layoff* (2009) expand the arena to the

politicised and informational. The intention is to comment, activate and disseminate through play, to counter traditional notions of games as merely diversion or entertainment whilst still being fun.

All of the above have been developed as intriguing and experimental indie games, but the question as to their definition as Artgames lies in the producer's and commentators intention. Tale of Tales's The *Graveyard* (2008) and *The Path* (2009), which explores an alternative fiction surrounding the fairy tale, 'Little Red Riding Hood', is considered an Artgame but never stated as such by the developers. Media arts crossover is evinced by the fact Tale of Tales began as Entropy8zuper, a renowned net art and design duo.

To continue the non-normative thread, David Surman at the Bad Games Colloquium (2009) in Bristol discussed Kuso-ge, literally translated as Shit-games and Baka-ge, idiot games, an Asian phenomenon where developers produce games that pastiche and parody existing game genres, particularly shooters. Although nominally not intended as Artgames, the transgressive nature of this kind of production is relevant and extends to other independent production. *Parodius Da* (1990) presents giant parrots with hiatus hernia as level bosses and the legendary *Cho Aniki* (1995) includes images of body builders in homo-erotic poses with player craft firing their protein upgraded "MAN BEAM" from holes in their heads. By contradicting normative gaming expectations developers can expand the remit of games culture and so, arguably, the horizons of gamers.

Parallel to this parody, the idea of "bad" games has also been taken to its extremes in games such as *Randy Balma Municipal Abortionist* (2008) by Mark Essen (messhoff.com), with its surreal visuals and frustrating gameplay compounded by a deliberately unusable control system. Other examples included Cactus Games's output such as *Mondo Medicals* (2007), surreal and deliberately but subtly contradicting accepted "good design" with unconventional cues or "disorientations."

What better way to question game tropes than deliberately negating what is considered normative? It takes skill and sensitivity to a medium to parody, to break and to question with such precision. To flip the premise of a favourite, yet now outdated, teaching tool, the Flanders and Willis 1998 book 'Web Pages that Suck: Learn Good Design by Looking at Bad Design', deliberately producing artefacts that challenge norms, Artgames and by extension the audience for Artgames, explore the underlying structures, mechanisms and narratives.

Moving on to Game Art, which has been defined as:

Any art in which digital games played a significant role in the creation, production and/or display of the artwork. The resulting artwork can exist as a game, painting, photograph, sound, animation, video, performance or gallery installation.

Bittanti, M (2006)

My own definition, with some assistance from Marc Garrett and Ruth Catlow (2008) owes also to Stockburger's (2008) notion of appropriation and approximation:

Games Art does exactly what it says on the tin: it is art that uses, abuses and misuses the materials and language of games, whether real world, electronic/digital or both. The imagery, the aesthetics, the systems, the software and the engines of games can be appropriated or the language of games approximated for creative commentary.

It is arguable that the intention of Game Art is to fit within and be distributed through the networks of a nominal notion of contemporary art and media art practice, mainly gallery based, rather than the networks a gamer may be nominally considered within. Unhelpfully for categorisation there are continual cross pollinations, and Artgames and Game Art co-exist happily in gallery contexts and other modes of presentation.

Examples of Game Art range from hacks of Nintendo games such as Myfanwy Ashmore's *Mario Trilogy* (2000-04) and Cory Archangel's *Mario Clouds* (2003) to Brody Condon's game engine recreations of paintings. Object-based works such as Condon's avatar sculpture *650 Polygon John Carmack* (2004), and Eddo Stern's gallery objects, *Kinetic Shadow Puppets (after Narnia, Segeal, World of Warcraft and Iraq)* (2007).

These extend the notion of Game Art from playable software and machinima to more traditional gallery artefact. Many of these works are not playable or are self-executing. Confusingly as Ashmore's *Mario Trilogy* has existed in both playable and non-playable forms, does its playable form enter the Artgame part of the scheme? Jeremy Bailey's *Warmail* (2008) expands this practice into live performative and collaborative

works, audience participation providing the collaborative element at a staged gallery event.

Finally, even though these definitions specifically focus on appropriation of digital games, they draw on a long history of artists' games and playful practice; notably that of Marcel Duchamp and Fluxus. These practices brought up to date with a reworking of Guy Debord's *Game of War*, now manifested in an online interpretation, *Kriegspeil* (200 8) by RSG.

BOSS BATTLE, ROLL CREDITS

These examples, regardless of category, inherently refer to their source; they comment directly on the game elements, practices and arenas that they appropriate, rather than just using a game engine or environment as a tool divorced from its roots. They break conventions through détournement and generate possibility. They are exciting, challenging, novel and fun.

TEXTS

Bittanti, M. (2006). *Gamescenes: Art in the Age of Videogames*, Johan & Levi.

Surman D. (2009) *Presentation at Bad Games Colloquium* [online] http://www.badnewthings.co.uk/playfulsubjects/index.htm, last accessed 10/08/09.

Catlow, R., Garrett, M., Morgana, C. (2008) *Games Art Networking Party website* [online] http://www.furtherfield.org/gamesart_networking.php, last accessed 12/04/09

Flanders, V. Willis, M. (1998), *Webpages that suck: Learn Good Design by Looking at Bad Design*, Sybex Inc.

Hatfield, D. (2009) *GDC 09: Hands-on IGF Award Winners* [online] http://uk.pc.ign.com/articles/967/967092p1.html, last accessed 10/07/09.

Levy, S. (1984) *Hackers: Heroes of the Computer Revolution.* Anchor Press/ Doubleday

Molleindustria, *Molleindustria Website*, [online] http://www.molleindustria.org/, last accessed 20/11/09.

Schleiner, A.M. (2008) "Dissolving the Magic Circle of Play: Lessons from Situationist Gaming," in *Homo Ludens Ludens*, Laboral Centro de Arte y Creación Industriel.

Stockburger, A. (2007) "From Appropriation to Approximation," in Mitchell, G. and Clarke, A. (eds) *Videogames and Art*, Chicago University Press.

Wark, M. (2004) *A Hacker Manifesto*, 4th ed., Harvard University Press.

GAMES
Achievement Unlocked (2009) by jmtb02
Cho Aniki (1995) by Masaya. published by Nippon Computer Systems Corp.
Kriegspeil (2008) by RSG
Layoff (2009) by Tiltfactor
Mightier (2009) by Ratloop Games
Mondo Medicals (2007) by Cactus Games
Parodius Da (1990) by Konami
Progress Quest (2004) by Eric Fredricksen
Racing Pitch (2007) by Jetro Lauha
Randy Balma Municipal Abortionist (2008) Mark Essen, Messhof
Spore (2008) by Maxis, Published by EA,
The Gaveyard (2008) Tale of Tales
The Path (2009) by Tale of Tales
This is the Only Level (2009) by jmtb02

Mousing Around with Jeremy Bailey
Ruth Catlow and Marc Garrett

Canadian artist Jeremy Bailey takes game and software interfaces as a site for performance and reflectivity in a détournement of the relationship between artist and audience. Described ironically as "a one man revolution in the way we use video, computers and our bodies to create art" (Frick 2005), Bailey dissects the ego of the white, male software developer in performances, at once both playful and excruciating, that reveal some toxic effects of techno-capitalism. In 2008 we invited Bailey to exhibit at HTTP Gallery in North London and commissioned a new performance for the opening night of *The Jeremy Bailey Show*. Alongside this exhibition of his recent works including *VideoPaint 3.0* and *SOS*, the private view guests would be co-opted into the meaning of the new artwork. At its core was an exploration of individual and collective agency in relation to hype surrounding the "participatory web" and the value placed on "collaboration" in today's art practice and policy-making.

The resulting commission *Warmail*, performed at HTTP Gallery on 9th September 2008, was a playful critique of contemporary games, performance and software art cultures, a pastiche of collaboration using videogame and computer vision technologies. Jeremy Bailey stood at a lectern on a raised platform "playing" the software artist and presenting his work to the gallery audience who were armed with "glo stix." They were chivvied and corralled into a "shrieking and dancing" performance in a "beta" performance of the game software that proposed to train them for a future of space travel, networked sociability and endless war.

The following extracts are drawn from an interview between Marc Garrett and Jeremy Bailey on Furtherfield.org's Netbehaviour.org email list in the days surrounding the exhibition opening and they expand on these themes.

MG | I want to begin by discussing *Warmail*, which will be performed with a participating audience at the HTTP Gallery

JB | *Warmail* evolved from HTTP's request for a piece that took collaboration into concern. I frankly have little tolerance for collaboration and it's uber inclusive oxymoronic brother audience participation. My thought is, whatever version of collaboration you subscribe to, the outcome is usually the result of whatever interface you chose to work under. A jam band is a good example. A terrible interface that results in vomit inducing tedium for the audience. SO! With that in mind, I have written a new piece

of software that I will demo with the help of the audience. The software is a "thin" email client. As in limited. It's all interface and it plays a bit like a game of asteroids. Think war/office hybrid. It also takes most of the direct control away from me, the author, and puts me in the role of conductor, which is a nice way of thinking about what an interface actually does.

As a group we will attempt to write an email to my mother, whom I haven't seen in a while due to overseas travel. The interface is controlled by the group's voice and body movements. Of course, the audience could overthrow this decision, and herein lies the opportunity to examine our primal desire for conflict. Every collaboration is fraught with it; the project just tries to make this as direct and obvious as possible. So, on Friday, using our collective shrieking and some dance moves we will decide to either get along and celebrate the woman who brought me into this world, or we will engage in a messy incoherent curse word peppered battle that leaves my mother wondering why she ever started using the Internet. Either way, I think we're going to have fun and we're going to feel something strange.

MG | You explore the "artist ego as a fragile instrument" so it seemed apt to go and look up Sigmund Freud's take on the matter. His writings on the subject reveal how a contemporary culture's dominant values play a large part in influencing (or perhaps shaping) perceptions and conclusions. He writes, "In a certain fashion he [the artist] becomes the hero, the king, the creator, or the favourite he desired to be without following the long, roundabout path of making real alterations in the external world" (Freud 1911). Another thing I find interesting about the artist and ego is that (personal) romanticism is an essential ingredient. The notion of the artist as a hero is a fascinating theme, which I personally experienced when I was much younger. Some of these moments are just too embarrassing and too tense to dwell on. It's funny reading the language of past canonical writings because the language is full of (unconscious) masculine-dominated mannerisms. Even though such concepts around the artist and ego are from long ago, I think that these psychological elements still remain. Your own exploration of these themes is explicit in your earlier performance video works such as Strongest Man[1] (and made even more so by the macho Jock-style comments that accompany the YouTube distribution).

1 http://www.jeremybailey.net/podcasts/strongestman.m4v

JB | Kickin' it up a notch with the Freud! Great stuff. The truth is, I started art school in the 90s and all of my profs taught identity politics. Actually my first EVER studio class was called "Women in Art" (I was the only man in the course). So starting out I always felt as though I wasn't allowed to make art. I wasn't a victim of any societal prejudices or discrimination; I was a very happy, privileged white man with very few cares. The type of work I make now, the type that casts me as an ignorant/naive modern artist playing with technology, was developed to try and create some justification for myself in an ocean of those more deserving than I. A friend of mine once commented in critique, "The more you win Jeremy, the more we lose." I've always thought that was a nice statement.

MG | Much of your work involves a GUI (Graphic User Interface). User interfaces as we generally experience them are tools for users to communicate with a computer. The interface defines the boundary between software, hardware device, and user. What is interesting is that in your work you are actually within the interface as well, performing in these environments. Could you talk about the relationship between you as the software developer and the software itself, within your performances?

JB | It has always been very important for my image or the image of the user to be a part of the interfaces I create. My reason has a lot to do with my historical/theoretical approach. I have been exposed to a lot of 1970s performance video and have developed a very keen interest in the theoretical context of the period; specifically, for what is termed "Performance for the Camera". It's a popular term, but for those unfamiliar, it specifically refers to a state as described in Rosalind Krauss's essay, "The Aesthetics of Narcissism" (1976), in which the artist becomes part of a feedback loop between him or herself and the electronics of the camera. This creates a unique self-awareness (reflextivity) that was not present prior to this time. Artists literally watche themselves (on a close circuit monitor) creating the work and responding simultaneously. To put this in perspective, take one step back in time and performances were created for live audiences (less feedback), take one step forward and we land in the digital era and our camera from the 1970s has become a computer (hyper feedback). I like to call what I do "Performance for the Computer," and it necessitates a re-evaluation of some of the psychological parameters that artists were working with in the 1970s. A lot of things have happened

between then and now; that's where things get very interesting. So with this in mindto answer your question regarding my role as a software developer, I'll have to tell a fable.

So, it's 1970, you're a performance artist, you've been doing performances all over the place, in studios, outdoors, in concert halls, the back of police vans... you've got little to no documentation... probably some photos, maybe some writing, maybe you're lucky enough to have some Super 8 footage and some halfway decent audio recordings. Consumer video comes along, the Porta Pack, wow, this is great! Cheap tape, sync audio, live previewing. But s**t, the thing is prone to unspooling when jostled, and to see what things look like you need a hefty monitor. Maybe it's not so great... but wait, you've got a studio, you could set up there and do all kinds of performances, watch them, adjust, finally get an idea of what/who you're working with. Ok, this is strange, if I turn the monitor toward me I can watch myself as if I were the audience. Hmmm... There's something different about this. I can't go on doing the same kinds of performances. Nope. This is brand new. Yay! Video Art is born!!

Ok, so fast-forward a decade. It's 1980; you're an upcoming electronic artist using computers to make amazing things happen in REALTIME! You have one problem: how do you document and show people what you're working on? Oh, of course!!! You record it on a Handycam! You pass the tapes around, copy them, they get copied, you end up representing your country at the Venice Biennial. Happy endings are great! Strange thing is you don't ever notice any of the things your friends noticed in the 70s, nope, you go right on making documentation on video without thinking twice about yourself as a performer. "I'm not a performer, I'm a programmer, my MACHINE is the artist, HE's performing, ask HIM what HE thinks! This shows you what he does, that's all" ... Ok... I'll do that, but don't you think your macho friend is making you look a little meek on tape? "Nope, that's the way I like it, I've put all of me into that thing, don't pay attention to me." Ok, I'm going to just say it dude, your machine's got a bigger d**k than you and you're a bit of a chauvinist for masculinizing it the way you are. I think you're using your machine in all kinds of weird ways and I think you should think about what it means to give yourself over to an object like that. I mean, seriously dude.

OK, let's fast forward 2 more decades. This thing called the Internet is popular, everyone has a computer, real-time video processing is on every CPU, we video conference with friends and family, augmented

reality is a burgeoning field. Yeah, we can do anything with our data selves, artists and non-artists alike. Yes! I'm going to share this video of me rotating photos and tossing them around using just my flailing arms to everyone in the entire world!! I look like an idiot? Why do you keep looking at me??! Are you gay? Yeah. That's it, I'm gay. F**k dude, would you realize what the f**k it means to warp your face with that ichat filter? PLEASE!

End of story. Guy is increasingly clueless, distractions are increasingly numerous.

So, I've used some colloquial language here to try and get a point across in impossibly high contrast. I play the role of the software developer in performances because I insist on forcing the acknowledgement that the computer is a site for performance and reflectivity. I am trying to use a laptop in 1975. I'm trying to understand what that means I guess.

HTTP Gallery – *The Jeremy Bailey Show*
http://www.http.uk.net/exhibitions/TheJeremyBaileyShow/index.shtml
Jeremy Bailey's Main Web Site
http://www.jeremybailey.net

REFERENCES
Frick, K. (2005) "The 12th New York Underground Film Festival." *FilmMaker* (21 April), [online] http://www.filmmakermagazine.com/archives/online_features/nyuff_2005.php, last accessed 19 January 2010.
Freud, S. (1911) "Formulations regarding the Two Principles in Mental Functioning."
Available at: http://www.wsu.edu/~kimander/biologyofart.htm, last accessed 19 January 2010.
Krauss, R. (1976) "The Aesthetics of Narcissism." *October* (Spring), pp. 50-64.

GAMES
Warmail (2008) by Jeremy Bailey

About the Journey, Not the Destination: Slow Gaming and an Interview with Bill Viola
Heather Corcoran

In *The Night Journey*, Bill Viola's latest work, there is no shooting, no running, no killing, no winning and no scoring. If you know Viola's work, you'd wonder why there would be. In the video art pioneer's lengthy career, these elements would be outright foreign – his videos and installations typically slow and tranquil. However, *The Night Journey* brings Viola's themes of enlightenment, spirituality and human consciousness to a new medium – videogames. And watching gamers acclimatize to a world where they can't go running around shooting things can be insightful.

Some players think the game is broken, mashing the buttons in hopes of eliciting some kind of quicker reaction before giving up entirely, carelessly tossing the controller aside. Others understand the game's pace but don't have the patience to see it through. These ones play absent-mindedly for awhile before placing the controller down, distracted by the next thing to see or do. But most are intrigued, and settle into this curious inaction. They spend time taking a closer look at the trees, hills and landscapes in front of them. They discover a control to reflect on the environment around them and are rewarded with a second layer of rich moving imagery – a blinking eye, or an odd shelter in the forest. A crowd forms. Spectators are immersed in the environment in much the same way as Viola's earlier work, experiencing the piece as a kind of navigated video. The player passes on the controller, letting someone else uncover the secrets of this game world.

There is slowly something developing at the fringes of of videogames. Pardon the pun, as the development is in fact slow. In opposition to the trend of fast-paced games that tempt the user to win faster and shoot more, Slow Gaming has become an almost movement comprised of developers and gamers alike. It has filtered to mainstream titles – the seemingly endless 'open' worlds seen in games like Grand Theft Auto, for example, give players countless hours of non-linear game time in addition to the main story objectives. Slow Gamers espouse the virtues of exploring absolutely everything because Slow Gaming is about appreciating the environment, and taking the time to reflect on it.

However, it is games by indie developers and artists that take Slow Gaming to its most interesting extreme, and test the boundaries of what makes a videogame a game at all. Its no surprise that artists have been Slow Gaming from early days. With a natural instinct to question and subvert the dominant culture, the commercial videogame industry – with its multimillion pound game releases – is an easy target. Indie developers

like Tale of Tales (with *The Path*) or thatgamecompany (with *Flower*) push the exploration of the games' environment to the forefront – unlike mainstream releases, there simply isn't a quick option for the speedier player. Cory Arcangel's *Super Slow Tetris* (2004) is an even more absurdly Slow Game – while it is almost unplayable, essentially an endurance piece meant to test rather than reward the player, its title alone makes the same point that *Flower* or *The Path* do – hold on, what's the rush?

If Slow Games question the quick pace of gaming to offer something more, then Viola – who has used extreme slow motion in his work as a trademark for decades – should have a lot to offer. The artist uses the technique to tackle the most fundamental questions of human consciousness, assigning meaning to the game that goes well beyond scoring a few points. In this interview Viola enlightens us as to the game's development and deeper significance.

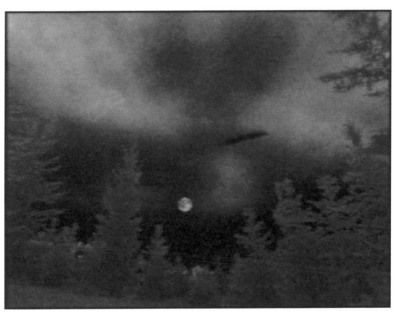

Bill Viola and USC Game Innovation Lab
The Night Journey
Photo: USC Game Innovation Lab

HC | Can you discuss the elements of your previous work that fed into the development of *The Night Journey* – how is there continuity between this work and what you've done previously?

BV | Next year will be my 40th year of creating artworks with electronic images. By chance, my personal lifeline, as well as my artistic practice, has paralleled the timeline of electronic or digital technology, starting with the television in the 1950s and leading right up to the digital age of high definition and videogames. In the 1970s, starting in university, I began an investigation into the properties of the then-new video medium, particularly the relationship between space and time. I used myself as subject in these works, as a live image or a first person point-of-view recording, and presented it on a monitor or a large projection.

In the early 80s I become interested in landscapes and created a series of poetical video films including recordings of mirages in the Sahara, Japanese culture's relationship to nature, and animal consciousness in a roaming bison herd or in zoo captivity. In the 1990s, I concentrated on large-scale room installation pieces, immersive environments that surrounded the viewer with images and sound. Then, in early 2000, after my father died, I began looking to the past and art history for inspiration, and consolation, and created a series of continuous-take pieces on the theme of suffering titled *The Passions*.

HC | So how did all this prompt a move into videogames?

BV | In 1998 when two people from Intel came to my retrospective exhibition at the LA County Museum, they were excited by the digital potential of the large room installation pieces in combination with my notebooks and writings. I envisioned creating a digital illuminated manuscript, and began conceptualizing the piece. We titled the piece *The Night Journey*, after the tradition of prophets, saints and shamans who take solitary out-of-body journeys to confront the Absolute. The project went through various stages over the following years, and in 2005, the producer Beau Takahara introduced Kira – my wife, partner and Executive Director of our studio, who makes all my projects possible – and I to Scott Fisher and Tracy Fullerton at the USC Game Innovation Lab. They immediately became excited by *The Night Journey*'s potential. With their team of core collaborators, we re-envisaged the work as a large-scale interactive digital world.

22

HC | With this work, you're entering into a medium, videogames, that has its own visual and formal language – such as side-scroller adventure games, or first person shooters. Did you draw on any of this established language?

BV | My approach to making a computer game is the same as my approach to making all of my artwork – spend as little time as possible looking at existing works by contemporaries. For inspiration I am more likely to look far into the historical past or deeper into myself and my life experiences than I am to analyze or respond to current trends in the field. After gathering sources around me, most of them literary and historical, I wait for the moment when I become overwhelmed and immobilized, and then put them aside. From this point I proceed more by intuition, inner visualization, and what the medieval mystics called 'The Cloud of Unknowing' – a state of creative emptiness that usually precedes breakthroughs. Over the years, I've learned how to hold a work in a state of incompletion up to the last possible moment to get the maximum creative tension out of it. It's a slow and sometimes frustrating process.

Using this process on *The Night Journey*, with my collaborators, has taken five years. Working this slowly and gradually was necessary given the content and visual language of the game. It has allowed the work to seep into our collective unconscious and dreams, and its meant that decisions coalesced naturally instead of being forced upon us by time, money and deadlines.

HC | But for example I find it interesting that the game is in the perspective of a 'first person shooter', yet the ubiquitous 'gun hand' most of these games use is missing. Was the use of the first person shooter perspective conscious, and did you recognize that people used to playing these kinds of games might pick up on the similarity in perspective?

BV | I feel that your emphasis on the 'first person shooter' point-of-view is a bit too narrowly focussed here. First person perspective is not only about line of sight. It has a long tradition in the arts of painting, sculpture, theater and cinema, all of which are part of the cultural root systems that have fed into games. In cinema, it typically signals a shift to the inner subjective state, as the camera transitions from external optical

perception to the inner visions of mental and emotional states of being. One of the core mechanics of *The Night Journey* is the user's ability to 'reflect', that is, to stop and look deeply into some feature in the landscape which in turn reveals a vision of another invisible dimension within that object.

Here, the heart of the interaction is to slow down and to see past the surface in a process of raw discovery. Looking deeply into things is rewarded, and this is only made possible by momentarily relinquishing control of the interaction and giving oneself to the vision. This mechanic of action and reflection is derived from many years of creative work in which I came to realize that the great artworks I was admiring contained equal measures of deliberate intention and serindipitous gifts – in other words, craft and revelation, the so-called 'leap of faith'. Video clips of my past works are used as visions in the game, and they are compiled as the player moves through the world into compound strings of images that emerge as dreams when darkness descends and the player's counterpart falls asleep. Finally, the world was designed to be completely accessible. The player is allowed to move freely anywhere within it.

HC | You touch on interaction there – how did you develop the interaction that players have in the game? Your work isn't typically associated with explicit interaction, and the interaction that players can have is very different than conventional computer games.

BV | Before embarking on this project, the interaction in my artworks was to be found not on the screen but in the room where the public encountered the images. In his study of paintings of spiritual visions, the art historian Victor Stoichita said, 'visionary ecstacy is the experiencing of an image that takes over the body of the seer'. He notes that people were regularly going into trance and bodily convulsions in front of these images. Maybe the Spanish artists and mystics of the 18th century were the precursors of videogames. In any case, it is clear that interaction in various forms has been a hallmark of art since its origins in the rituals within the Paleolithic caves.

The gameplay and modes of interaction in *The Night Journey* started with the look of the world. In the 1970s, I had picked up a low light surveillance camera at a swap meet. It possessed one of the most unique and interesting image qualities I had ever seen – grainy, black and white, with an image that smeared when the camera was moved too fast. I brought

some footage from it to the USC Games Lab, where our programmer was able to create a digital version of the camera's look for the entire world. So from the very start, the player senses a subjective feeling to the world.

The second important element was to slow the action way down so that the pace of interaction was in tune with a solitary reflective experience. We wanted the landscape to reveal its secrets subtly and gradually. If the player races through it, they might have an interesting experience visually and enjoy some cool smearing effects, but they will not see below the surface.

HC | You were of course influential in the development of video as an artistic medium. Can you offer any insight into the parallels between the development of video and the development of videogames as a viable artistic medium? There are now a number of artists who are working in the field of videogames – how does your piece dialogue with them?

BV | The best dialogue I can think of is between the artists and his or herself on the deepest, most intimate level – the dialogue between self and soul. Everything else is secondary. Over the years we have been creating The Night Journey it has been very rewarding to see a new generation of artists emerge and take on videogames as a creative medium of personal expression. It is now time to expand the scale, scope and historical reach of games as valid art forms on par with the great works of the past.

GAMES
Flower (2009) by Tale of Tales
Grand Theft Auto (first released 1997) by DMA Design
The Night Journey (2009) by Bill Viola and USC Game Lab
The Path (2009) by thatgamecompany
Super Slow Tetris (2004) by Cory Arcangel

From Parasitism to Institutionalism: Risks and tactics for game-based art
Daphne Dragona

Game-based art kicked off back in the nineties, with the rising of net culture and hacktivism. The releasing of the codes of popular games such as Doom and Quake offered the opportunity to users to intervene in gaming environments, to appropriate and modify their structures and elements, providing a new terrain for creativity. This first game-based scene was characterised as "parasitic," as it was dependent on the commercial game platforms of the period whilst at the same time attempting to transgress and subvert them (Schleiner 1999). Blurring the boundaries between producer and consumer, artist and viewer, game fan and game developer, programmer and hacker, the parasitic game culture of the late nineties opened up a new horizon for the emergence of creative and critical approaches to digital gaming platforms.

Game-based art is no longer "a new thing." A decade later, the field has evolved and changed; it has matured and become both established and respected. One needs only to realise the transition from the first game projects' presentations to today's game art shows. While, for example, Anne-Marie Schleiner's online exhibition Cracking the Maze, and Steve Dietz and Jenny Marketou's Open Source Lounge in the Medi@terra festival at the turn of the decade, focused on parasitic interventions and modifications of game environments, the exhibitions organised by Stedelijk Museum in Amsterdam, Laboral Center in Gijon or Itaú Cultural in Sao Paolo over the last few years have showed that game-based art is becoming a field that art institutions now wish to invest in.[1] This impression is strengthened by the fact that games now constitute a "category" for media art festivals and are becoming an axis for centers' and museums' programs and activities. This field of artistic creativity has greatly expanded. The game patches and modifications of the past opened the way to a vast array of techniques and practices that now take the form of game applications, interventions, performances and installations that offer those unique opportunities for participation and interaction that the contemporary institutions seek.

1 Cracking the Maze: Game Plug-ins and Patches as Hacker Art (1999) was an online exhibition curated by Anne-Marie Schleiner that hosted downloadable patches and games by artists, implying creativity outside some kind of institutional system and control (http://switch.sjsu.edu/CrackingtheMaze/index.html.) The Open Source Lounge, an event organised by Steve Dietz and Jenny Marketou, took place in Athens in 2000, in the context of Medi@terra International Art and Technology Festival. Its aim was to serve as a platform for people from the media arts field to express and exchange ideas on open source, hacking, and parasitic interventions. Several exhibitions on games have been organised by institutions. Examples include Next Level: Art, Games & Reality in the Stedelijk Museum of Amsterdam in 2006, Gameworld, Playware and Homo Ludens Ludens in Laboral Center for Art and Industrial Creation of Gijon in 2007 and 2008, and Gameplay in Itaú Cultural of Sao Paolo in 2009.

But, have we already reached the time for another institutionalisation of an art form? Although the passage from a marginal, parasitic act to one embraced by institutions is not so uncommon for art, in the case of game-based art, a new oxymoron is developing, this time around play. Can games be presented in institutions? Do they become "objets d'art"? What kinds of relationships are being formed between games, artists, visitors and institutions? Even if the opposition between artists and institutions is old in art, new encounters and questions emerge when playfulness is involved.

A CASE OF DÉTOURNEMENT

Discussing game art in the context of art history brings movements of an anti-art and anti-conformist character back to the foreground. Dada, Surrealism, Situationism and the Fluxus, '"movements" of the 20th century (although some of their practitioners and believers would disclaim the term) seem to be the closest predecessors. Having social and political ideological positions and statements, and aiming to challenge society's and art's stereotypes, the artists of these movements used play as a means to provoke, reverse and reveal structures and to offer new readings and ways of understanding. Their manifestations, works, performances and events were taken to the cafés and to the streets, away from galleries and institutions, opposing hierarchies, truths and systems. Play was called to take on a "revolutionary" role following their tactics and positions. Dada's playful spirit, the Surrealists' emphasis on the imaginary, Fluxus's impossible-to-play games and the Situationists' call for a burst of play into life contributed to the acts of resistance that artists and writers were trying to shape.

Using play as a practice to transcend rigid forms and to break constraints is a distinctive feature of today's game-based art. Artists working in the field are playing with the rules, rather than playing by rules; they modify or negate instructions, structures, aesthetics and norms, seeing contemporary gameworlds as a reflection of the contemporary digital realm.

This merging of creativity with playfulness has been connected to détournement, a Situationist term describing appropriation and subversion, an act of "an all embracing reinsertion of things into play whereby play grasps and reunites beings and things" (Vaneigem 1967). The use of the term for the art practices being developed in game contexts implies processes of appropriation not only of game features, assigning to them new properties, but also of concepts and ideas, assigning to them new meanings. In this

context, for example, Brody Condon's animated re-makings of the late medieval paintings, Cory Arcangel and Paper Rad's hacked cartridges for *Super Mario Movie*, Joseph DeLappe's interventions in multiplayer games and virtual worlds, or Personal Cinema's transformations of social media platforms into gamespaces, all are processes of appropriation and subversion that alter the standard norms and common uses, aesthetics and behaviors of the gaming environments.[2]

Détournement expresses the old battle between play and game and reasserts games' playfulness through art. Opposing the disciplined, structured, antagonistic and rule-based form that western European thought assigned to games simulating the real world itself, artists' acts stand out as playful tactics of resistance that aim to break systems and strategies. Reclaiming play as a disposition and an instinct that aims to reverse imposed systems of thought and order, the practices of artists working on games constitute a continuation of forms of art embracing critique and resistance. The approaches and tactics of subversion bring especially to mind the practitioners of institutional critique of the sixties, eighties and nineties; that is artists whose work challenged the institutions of art by criticising their functioning, their value system, their hierarchies, mechanisms and strategies. Observing the rules, the impositions and the structures of the institutions, those artists aimed to subvert them with practices similar to those of the artists working on games. Looking back to Christo's *Wrapped Museum of Modern Art*, Claes Oldenburg's *Mouse Museum* or Krzysztof Wodiczko's large outdoors political projections on institutions, one can recognise the role playfulness, irony and profanity had in the process and realisation of their work.

If game art follows such a tradition of anti-conformist and anti-institutional art practices embracing playfulness, transcendence and subversion, what could its possible role in an institution be? And what does integration in an institution mean? A deprivation of its inherent characters or an outburst of play's features to the institution itself?

There is already a rather long list of game art exhibitions, many of them organised by museums or centers where game projects have been

2 Relevant works include:*Judgement* (2008), *Resurrection* (2007), and *DefaultProperties()*;(2006) by Brody Condon, (http://www.tmpspace.com/); *Super Mario Movie* (2005) by Cory Arcangel and Paper Rad (http://www.beigerecords.com/cory/Things_I_Made/SuperMarioMovie); *dead –in – iraq* in *America's Army* (2006-ongoing) and *The Salt Satyagraha Online: Gandhi's March to Dandi in Second Life* (2008) by Joseph DeLappe (http://www.delappe.net); and *Folded In* (2008) by Personal Cinema (http://www.foldedin.net).

exhibited as contemporary artworks, "properly positioned" and distanced from each other, sometimes even in showcases, discouraging interaction. Processes of archiving, documenting, exhibiting and collecting games are neither surprising nor unusual. After all, games compared to the other forms and movements of art discussed above are easy-to-perceive-and-collect items, as they are in fact "cultural objects bound by history and materiality" (Galloway 2006: 1). Moreover, if we look back, the movements of art mentioned above did not succeed in escaping institutionalisation and commodification in the end. Despite their manifestoes and positions, their works sooner or later became parts of glorifying retrospective exhibitions that attracted thousands of people. Celia Pearce (2006), a game artist and educator, has interestingly noted, "There is deep and tragic irony in going to an exhibition of Fluxus artifacts... Objects whose entire purpose was to elicit play exist now only as the corpses of their former selves, trapped in a 'Mausoleum' within the object-centric commodity-based world of Art with a capital A..." (70). Similarly, art based on institutional critique also became a form of art presented by institutions themselves, with the exhibition entitled The "Museum as a Muse" being possibly the best example of a retrospective group show on institutional critique (McShine 1999). What, therefore, would accordingly be the case for game art? Are we talking about new contemporary art commodities in the form of games, or new forces, actions, tactics driven by play that could escape institutionalisation and reverse the mechanisms of commodification?

Surprisingly games and institutions seem to have a lot in common. They are both well-structured systems, forming hierarchies, based on rules and time and space constraints. In exhibitions, worlds are being created and stories are being told, forming environments separated from the everyday life, just like happens in the "magic circles" the games form. The microcosms being built in both cases, either based on fantasy or on any historical, social or theme context, invite users/visitors to find a place in them, to empower their identity and to often associate with certain elements of a social or societal status that are being represented (Caillois 1958/2001: 13, 43, Huizinga 1955: 13, Sutton Smith 2001/1997: 91 - 95, Duncan 1995: 7 – 20).

The detachment from everyday life, the imposition of rules, and the formation of a specific space are all elements that favor idealisation and sacralisation of ideas and items. Although a side of play has been associated with rituals in the past as Huizinga noted, a sacralisation of contemporary

forms of play can only lead to a sterilisation of its inherent features (1955: 20, 21). As Raoul Vaneigem (1967) wrote in his *Revolution for Everyday Life*,

> The game dies as soon as an authority crystallises it... In the realm of the sacred...rituals cannot be played with, they can only be broken, can only be transgressed. Only play can deconsecrate, open up the possibilities of total freedom. This is the principle of diversion, the freedom to change the sense of everything which serves Power; the freedom, for example, to turn the cathedral of Chartres into a fun-fair, into a labyrinth, into a shooting-range, into a dream landscape.

Vaneigem as well as Agamben later saw profanation and transgression as play's most important features against any form of sacralisation imposed by any kind of authority (Vaneigem 1967, Agamben 2005/2006: 117). "Free subjective play," already introduced by Schiller and Kant in the Enlightenment, was significant for its capacity to catalyse the different quality standards imposed (Schiller 1999, Guyer 1998, 2004).

On this ground, if play is to be understood as a force driven not only by imagination but also by critical thinking, subjectivity, diversity and freedom, then its placement in exhibition contexts becomes a form of subversion, innovation and transformation for the institutions themselves.

A DIFFERENT BASE FOR INSTITUTIONAL CRITIQUE

To situate the role that play and games have or may have within an institution today, one needs to take into consideration the various parameters that have emerged in the last twenty years. Living in the "Network Society" as Castells framed it, in an era that has fragmented places but connected distances, one's identity is formed by a continuous interaction with the diverse, multicultural elements one is confronted with (Castells 2000). In this frame, institutions necessarily need to pass from a material to a symbolic representation. They are called to play a new role within new societal conditions and art's critique towards them needs to take into consideration the new merging of life and work and the precarity people are confronted with.

Game art emerged in such times of interconnectivity, when the space of flows took over the space of places. Independent from whether the actual game projects are offline or online, within game spaces or inspired by them,

artists today need to address a multitude of players, different subjectivities, whose time, disposability, sociality and playfulness constitute the latest expression of affective labour. At the same time, the merging of the virtual with the real and the fragmentation and chaos of the era of the network have formed a new terrain for play that expands beyond screens or walls, surpassing space constraints. Pat Kane (2004), discussing the changes wrought in this time of the network society and the passage to an intense precarity of life and work, emphasises that the function of art then within this connected but chaotic reality, can only be to provide unifying experiences that players enjoy despite their innate diversity and differences (226).

The role of play within institutions can be a reflection of the role that play is called to take on in our social and political reality. Play might not need to frame a new kind of institutional critique but in a different direction, it is needed to encourage the taking of a conscious stance within institutions and within society. What is expected from art practices is the force for a movement, a change and a transformation. As Geert Lovink (2008) has pointed out we are in need of an art that assists, engages, and appropriates knowledge, not an art that principally criticises. (51) Such a force could be provided by play joined by creativity and collaboration. Play's openness, unpredictability and uncertainty can change the common norms and allow more room for communication, interaction and dialogue.

In a world that is disordered but shared, a disconnection from sacralisations and hierarchies seems to be possible by those who are ready to play – to improvise and take risks for future possibilities. Today's institutions are expected to allow room for those players. There is a chance then that the shared playground that will be created will connect not only audiences, artists and institutions, but also experiences, realities and diversities.

REFERENCES

Agamben, G. (2005/2006) *Profanations*. Agra Editions.

Caillois, R. (1958/2001) *Man, Play and Games*. University of Illinois Press,

Castells, M. (200) *The Rise of the Network Society: The Information Age: Economy, Society and Culture Vol 1* (The Information Age). Blackwell.

Duncan, C. (1995) *Civilizing Rituals Inside Public Art Museums*. Routledge.

Galloway, A. *Gaming: Essays on Algorithmic Culture*. University of Minnesota Press.

Guyer, P. (1998, 2004) "Kant, Immanuel." In E. Craig (Ed.), *Routledge Encyclopedia of Philosophy* Routledge, London. http://www.rep.routledge.com/article/ DB047SECT12, last accessed 09/07/09.

Huizinga, J. (1955). *Homo Ludens*. The Beacon Press.

Kane, P. *The Play Ethic: Manifesto for a different way of living*. Macmillan.

Lovink, G. (2008) *Zero Comments: Blogging and Critical Internet Culture*, Routledge.

McShine, K., ed. (1999) *The Museum as Muse*. The Museum of Modern Art.

Pearce, C. (2006) "Games as Art: The Aesthetics of Play," *Visible Language* 40, no. 1: 70.

Schiller, F. (1794) *Letters Upon The Aesthetic Education of Man*. http://www. fordham.edu/halsall/mod/schiller-education.html, last accessed 10/06/09.

Schleiner, A.M. (1999) "Cracking the Maze, Game Plug-ins and Patches as Hacker Art," http://switch.sjsu.edu/CrackingtheMaze/note.html, last accessed 15/06/05.

Sutton-Smith, B. (1997/2001) *The Ambiguity of Play*. Harvard University Press.

Vaneigem, R. (1967) *The Revolution of Everyday Life*, http://library.nothingness. org/articles/SI/en/display/212, last accessed 20/02/08.

GAMES

Super Mario Movie (2005) by Cory Arcangel and Paper Rad

Judgement (2008) by Brody Condon

Resurrection (2007) by Brody Condon

DefaultProperties(); (2006) by Brody Condon

dead-in-iraq (2006-ongoing) by Joseph DeLappe

The Salt Satyagraha Online: Gandhi's March to Dandi in Second Life (2008) by Joseph DeLappe

Folded In (2008) by Personal Cinema

Plates

Mousing Around with Jeremy Bailey
Ruth Catlow and Marc Garrett, p.15

→

Warmail. Jeremy Bailey, 2009
Performance documentation HTTP Gallery
Photograph by Paul Ros

Strongest Man. Jeremy Bailey, 2003.
Video Still

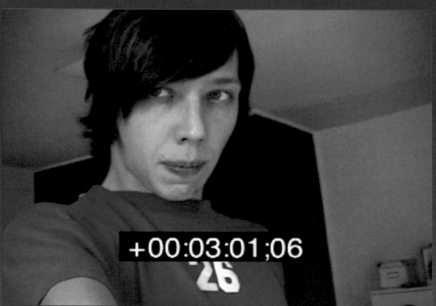

+00:03:01;06

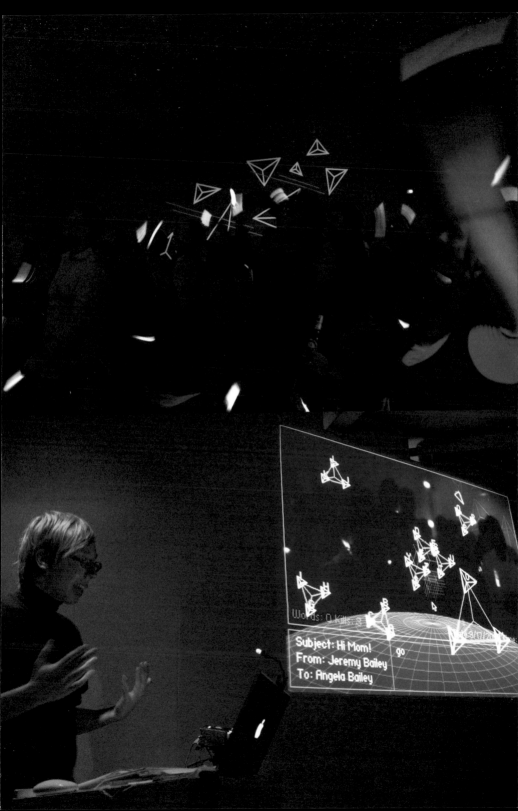

Creating Critical Play
Mary Flanagan, p.49

Layoff. Tiltfactor, 2009.
Game stills

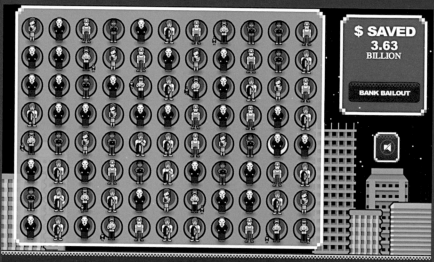

$ **SAVED**
3.63
BILLION

BANK BAILOUT

After Merrill Lynch CEO John Thain was hired in 2008, he used 1.2 milli

UNEMPLOYMENT OFFICE

Massively Multiplayer Soba. Tiltfactor, 2008
Game Documentation

Ludic Interfaces
Matthius Fuchs, p.54

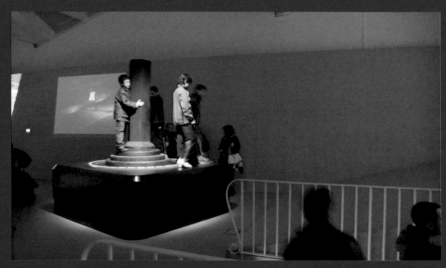

[giantJoystick]. Mary Flanagan, 2006.
Exhibited LABoral Art and Insustrial Creation Centre

The centre of the universe has infinite paths of approach. Jess Kilby, 2008

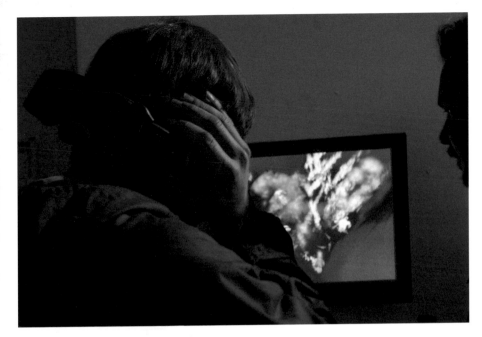

CarnageHug. Corrado Morgana, 2007
HTTP Gallery. Photo Paul Ros

Wargame. Leif Rumbke, 2005

RSG's Kriegspeil, an interview with Alex Galloway
Marc Garrett, p.60

Kriegspiel, RSG, 2008.
Game stills

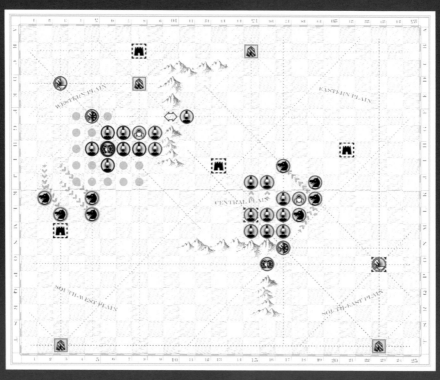

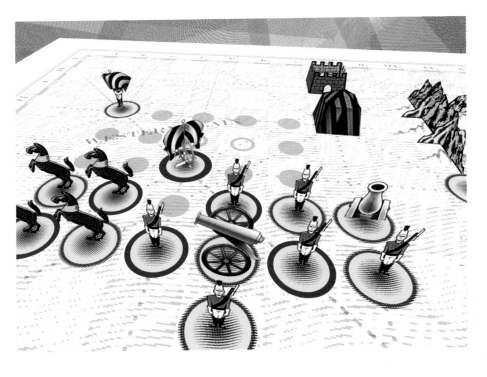

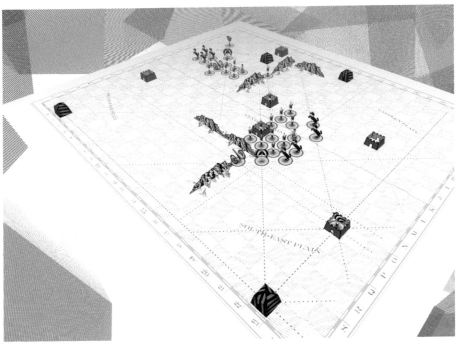

Freedom of Movement Within Gamespace
Anne-Marie Schleiner, p.65

Playing with the Gothic:
If you go down to the woods tonight...
Emma Westecott, p.79

→
The Path, *Tale of Tales*, 2009.
Game still

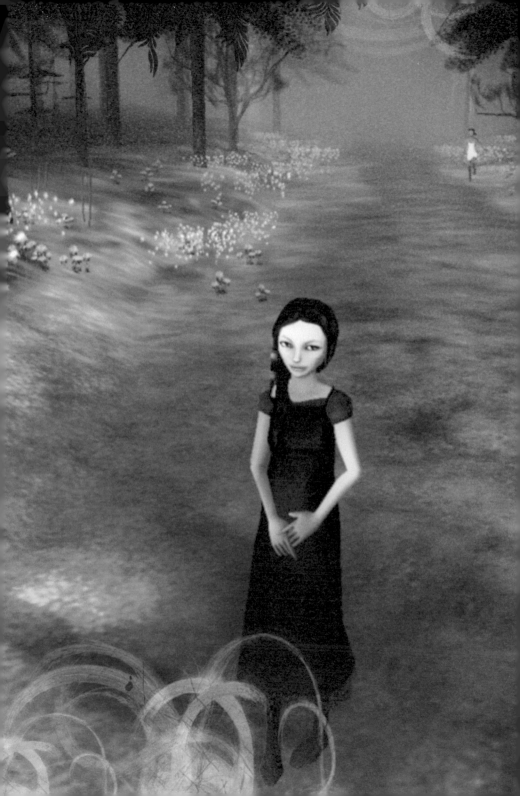

Creating Critical Play
Mary Flanagan

In his landmark essay "Some Paradoxes in the Definition of Play", psychologist and "flow" theorist Mihalyi Csikszentmihalyi (1979) asked, "How is it possible for play to be both divorced from reality and yet so rife with real-life consequences?" (14). For contemporary artists and game designers, especially those wishing to design for complex, multivarious, and critical play, this observation alludes to one of the core challenges of creating games moving towards social, political, aesthetic, or educational aims. Simply phrased, designers of serious games must often "answer" for the effects of their serious game on larger communities far more frequently than, say, a documentary filmmaker must justify the after-effects from a particular film exposé, or an artist making a critical painting. Designers of serious or social issues games face the additional possible appraisal of making light of the "real world" issues they intend to bring into conversation. Luckily for those interested in the intersection of real world issues and play, there are significant and meaningful precedents in both theory and practice.

Artists have long taken on social themes such as war, social inequity, and political power in the form of game-related work. From Alberto Giacometti's game board-related artworks in the 1930s to Yoko Ono's all-white chessboard, *Play It By Trust*, in the 1970s, artists have seen games as frameworks for thinking about culture. The New Games Movement during the late 1960s and early 1970s reaffirmed a repeated human belief that play is good for addressing social issues through its large scale, publicly launched play events in California. These trends were reflected in theories of contemporary philosophers and writers.

Today, game designers and new media artists translate such restructured approaches to reality into palpable worlds, and render these as marvelous, addictive, spellbinding experiences. Players push at the edges of these varied playspaces, discovering their inherent principles, possibilities, and limitations. Here, I wish to briefly survey two game works – a street game and an online game – to touch on how a critical praxis functions in the development of mechanics and gameplay. Games, both digital and analog, offer a space to explore creativity, agency, representation, and emergent behaviour with rules. They also quite literally fashion rule-space as a reality-space. How do designers use games to express ideas about crisis, power, and identification?

In autumn of 2008, the Tiltfactor laboratory at Dartmouth College created a large scale collaborative urban game, *Massively Multiplayer Soba*. *Soba*'s first launch was as an urban, location-based game that took place

in the Queens area of New York City. The game launched in New York at the Conflux psychogeography festival. *Soba* invited players to "grab some friends and traverse remarkable neighborhoods in New York City... Talk to strangers, find clues, and fetch ingredients for a giant collective noodle party!" Designed to be a team-based urban game focused on culture, food and language, the game-event enticed players to the non-tourist neighborhoods of New York, combining play with opportunities to mix with new places in the city, and ultimately take a meal in a collective dinner with local people, intentionally mixing players with non players. This design created unexpected encounters with residents while challenging concepts of culture and language through storytelling and discovery.

The intent of *Soba* was to embody the human values of tolerance and diversity - not only in the theme of the game but in the game mechanics themselves. For example, the teams of players carried clues in multiple languages which were designed to foster player interaction with non-players in the community. Points were awarded primarily based on the complexity and depth of the interaction, rather than the "scavenger hunt" style claiming of facts, objects, or territories. The design allowed for a variety of play strategies: collaboration for those who may not be competitive, or specialisation for those who excel at particular kinds of challenges. Play was combined with the opportunities for engagement to allow for game players to mix and interact with residents in meaningful ways, while challenging preconceptions of race and language. Rather than simply using these neighborhoods as host sites in which the game took place, these communities were central to the focus of *Soba*, with longer interactions and storytelling exchanges with community members as the central goal of the project. Since, other iterations of *Soba* have occurred in new neighborhoods and with new menus, such as *Soba Shanghai* and *Massively Multiplayer MuShu* in Hell's Kitchen (2009).

Using games to explore complex ideas is a relatively new phenomenon, but this is not because games are not necessarily the right medium, or because play cannot be complex. There is simply not a great mass of games used in this way yet. One of the things that is attractive about games and play is the sense they offer for encountering something special – games may provide a framework for a new system of thinking, or offer glimpses of divergent logic. Play, both in an open sense and within the structure of a game, can serve as a lens for creating something beautiful. In other words, games are systems for imagining what is possible. Games

and play environments are particularly useful frameworks for structuring systemic and conceptual concerns due to their multifaceted and dynamic, rule-based nature.

Games, functioning as a technology for creating social relations, work to distill or abstract the everyday actions of the players into easy-to-understand instruments where context is defamiliarized just enough to allow for what John Huizinga (1955) famously refers to as the magic circle. Play, then, relies on shifting realities or world views- transformations that transpire when one submits to chance elements such as financial success, camaraderie, or notability. The presence of multiple, simultaneous realities leads Csikszentmihalyi (1979) to the conclusion that, "what play shows over and over again is the possibility of changing goals and therefore restructuring reality" (17).

The notion of an "activist game" is developing with the emergence of games that address social issues gaining new audiences over the past decade. Contemporary game makers who are not necessarily identifying as artists have tackled social issues from poverty (*Ayiti*, Global Kids and Game Lab) to the fast food industry (*McDonald's Video Game*, Molleindustria) to terrorism (*September 12th*, Gonzalo Frasca). These games make relevant particular social issues to new audiences, and they also explore notions of agency and education.

In March of 2009, the Tiltfactor laboratory released the causal game *Layoff*, reaching a million players within a week of the release. A look at the core mechanics of the game can reveal the transformative possibilities through "critical" play. A darkly humorous game, players of *Layoff* engage with the game from the side of management needing to cut jobs and increase workforce efficiency by matching sets of workers. Upon release of the game, record numbers of workers had been laid off and financial institutions were receiving trillions of dollars to bolster the struggling economy. The changing state of economic affairs made more and more poignant the core point of *Layoff*.

Games are particularly well-suited to supporting educational or activist programs in which the fostering of empathy is a key outcome. This is because games allow players to inhabit the roles and perspectives of other people or groups in a uniquely immersive way. In *Layoff*, as players eliminate play from the side of management needing to cut jobs, and match types of workers into groups in order to decrease redundancy and increase workforce efficiency. Players eliminate many workers in a row they find that

as they gradually replace the workers with less skilled or lower paid new workers, bankers and financiers take the place of the working class jobs. The financiers in the game do face layoffs, and they may be moved in order to address redundancies with other worker groups.

Layoff is not intended to be an accurate model of the layoff process. It is not a simulation. Rather, Layoff inspires dialogue between players and tension in the values within the game. The ambiguity that Layoff imposes upon its players resonates with the "poetics of open work" as described by theorist Umberto Eco (1962/2006) as a system of symbols and communication for indefinite, open, interpretive, and shifting positions. Within this sense of openness:

> The work remains inexhaustible in so far as it is 'open', because in it an ordered world based on universally acknowledged laws is being replaced by a world based on ambiguity, both in the negative sense that directional centers are missing and in a positive sense, because values and dogma are constantly being placed into question (28).

While Eco did not begin by formulating a theoretical framework for thinking about games, Layoff's embedded contradictions reflect the sense of ambiguity that also characterizes the themes of an "open" work. The design of the game was intended to foster, in part, a crisis of empathy as the workers are laid off during real-world economic collapse.

Csikszentmihalyi (1979) insisted that the term "play" be read as a negotiation between subjective and objective reality, but he cautioned, "reality is not an invariant external structure" (17). In this, he hinted that the whole of human experience and human values are continually in flux. In response to this potentiality, French theorist Gilles Deleuze (1990) offered a compelling argument for the importance of systems like games, noting that the desire for the "other" is, in fact, a yearning for a structure that can become an "expression of a possible world: it is the expressed, grasped, as not yet existing outside of that which expresses it" (307). If games are possible worlds, the presence of many parallel realities through time for any individual leads Csikszentmihalyi to the conclusion that, "what play shows over and over again is the possibility of changing goals and therefore restructuring reality" (17). Games are reality engines, frameworks for meaning making.

Interestingly, this is a similar conclusion reached by art critic Nicolas Bourriaud (2002) about trends in contemporary art of social relations forming due to the intervention of an artwork. Indeed, early on in his influential treatise *Relational Aesthetics*, Bourriaud notes, "Artistic activity is a game, whose forms, patterns and functions develop and evolve according to periods and social contexts; it is not an immutable essence" (11). Later in his text, he claims, "Art was intended to prepare and announce a future world: today it is modeling possible universes" (13). Through these observations and the preceding game works, we can easily see that these works are works of social relations, and that games facilitate these perhaps more than other forms. The similarities between the artwork and the game are recognized in both the studio and in theoretical circles. Games offer the artist, critic, and social designer the possibility of sculpting cultural practice of contemporary importance.

REFERENCES

Bourriaud, N. (2002) *Relational Aesthetics*. Dijon: Les Presses du Réel.

Csikszentmihalyi, M. (1979) "Some Paradoxes in the Definition of Play." *Play as Context*, ed. Alyce Taylor Cheska. Leisure Press.

Deleuze, G. (1990) *The Logic of Sense*. Trans. Mark Lester and Charles Stivale, ed. Constantin V. Boundas. Columbia University Press.

Eco, U. "The Poetics of Open Work" (1962). In: *Participation: Documents of Contemporary Art*, ed. Claire Bishop. Whitechapel.

Flanagan, M. (2009) *Critical Play*. MIT Press.

Huizinga, J. (1955) *Homo Ludens: A Study of the Play-Element in Culture*. Boston: The Beacon Press.

GAMES

September 12th (2003) by Gonzalo Frasca

Aviti (2006) by Global Kids and Game Lab

McDonald's Video Game (2006) by Molleindustria

Layoff (2009) by Tiltfactor

Massively Multiplayer Soba (2008) by Tiltfactor

Ludic Interfaces
Mathias Fuchs

Years before the Wii console made a gaming audience refocus from content to interface, artists explored new forms of man-machine, machine-machine, and machine-woman interface configurations. Pieces like Jeffrey Shaw's *The Legible City* (1988), Mary Flanagan's *[GiantJoystick]* (2006), Leif Rumbke's *Wargame* (2005), or Jess Kilby's *The center of the universe has infinite paths of approach* (2007) are art games with unconventional interface concepts based on playfulness as the main design objective. We will call these interfaces "ludic interfaces" to distinguish them from technically engineered interfaces like the ASCII keyboard or the mouse. The installations, tools and concepts differ from traditionally engineered systems as they are often playful, rich in connotative power and surprise, custom-built, aware of regional and historic context, critical, and inviting of co-creativity, user-generated or user-driven content (or radically opposing those possibilities).

Ludic interfaces take the best from computer games, artistic experiments, interactive media, media conversion, social networks, and modding cultures to offer tools which are adaptive to cultural specificity and cultural change, and are sensitive to gender-related, age-related and ethnic specificities.

Jess Kilby's *The center of the universe has infinite paths of approach*, an RFID-enabled tarot card table, consists of a hand-painted black table with letters and signs drawn upon it and a white set of cards containing radio-frequency tags. The installation is an example for a ludic set-up where the interface contributes significantly to the magic of the game. Hidden information within the blank cards allows the RFID reader, a digital tarot reader automaton, to interpret information hidden from the human eye. Kilby's system interprets the information contained within the cards and displays videos of a frightening future. The game could certainly be implemented as a Flash simulation or be built for a 2D monitor display system, but without the materiality of the ludic interface, without the special lighting, and without the artist dressed in a fortune teller's outfit the game would be radically altered

The same holds true for Mary Flanagan's *[GiantJoystick]*, an enormous playable Atari joystick. It is the interface with all its materiality, erotic connotations and haptic features which makes the ludic installation work so well.

THE INTERFACE IS THE MESSAGE

If we conceive games as a system, a set of rules, a player, physical or virtual objects to play with, and a regional and historical context to be played in, we could try to find meaning in different aspects and aspect relations of the game. One could find meaning in the rules and the development of moves within the rule-system. One could alternatively search for meaning in the role the player adopts in the game. In particular the player's position in a socio-historical context could be interpreted as the meaning of the game. Another approach is however to interpret the interface between man and machine, machine and machine, or woman and machine as the crucial element in the production of ludic experience and ludic meaning. I want to call these approaches systematic, role-based, socio-historic, and interface-led.

Ludic interfaces lend themselves to shift focus from rules and roles to processes of deconstruction of rules, roles and socio-historic settings. For this reason game art often focuses on the interface – or, as I will demonstrate later, on an apparent lack of interactivity within the interface provided. Both approaches, i.e. the deconstruction of interfaces or the destruction of meaningful interface functionality, are artistic strategies to criticise commercial interface design and to suggest provocative alternatives to middle of the road interface standards. Ludic interfaces and Zero interfaces contain artistic statements intended to oppose ideological concepts in HCI (human computer interaction) and to set free playfulness in the process of (wo)man-machine communication.

LEAVING THE MAGIC CIRCLE?

The level of "lusory attitude" (Salen and Zimmermann 2004) that a game can provide seems to be enhanced by the interface used to play the game. A joystick glues the gamer's hand to any space fighter action game, a steering wheel feels good in the hands of someone playing a car racing game. On the other hand a fire button might alienate a gamer from conducting eco-friendly simulations and a rocket launcher device seems to be of little help for Mattel's *Barbie Goes Shopping* game (except in the case of extremely cynical gamers). The interface also sets up a tacit agreement on how to play and how not to play. A steering wheel device with a gas pedal connected to it imposes constraints upon the player's actions. It clearly suggests going right or left and accelerating or decelerating. The setup does not encourage us to go up and down, because steering wheels are not designed to control

Z-axis moves. The interface is therefore as much of an inhibiting device as it is an enabling one. We are controlled by the interface's constraints when we think that we are in control. Technically engineered interfaces are ideological in this regard, as they contain implicit rules, where we least expect them. Ludic interfaces and game art pieces like the ones mentioned above point our attention towards the potentially wide range of interaction patterns that we are usually not invited to partake in. Ludic interfaces oppose the ideological aspect of technically engineered interfaces by ridiculing their functionality or by opening up the field of possible interaction. In many cases ludic interfaces are build on the attitude of the trickster, the spoilsport or of the cardsharp.

Being a spoilsport is common artistic practice and artists like Tracey Emin demonstrate that neglecting the rules can be a lot of fun. It can also be serious business, as the example of Marcel Duchamp proved when he allegedly quit art-making for the sake of chess-playing. In 1923 Duchamp declared that chess "has all the beauty of art – and much more. It cannot be commercialized. Chess is much purer than art in its social position." He was immediately interpreted by art critics as having renounced art for chess, which he actually never claimed. The spoilsport act of playing chess in an art context created a debate situated in an art context and thereby built a magic circle around Duchamp's activity which was seen by many as destructive of the art circle's magic. From a historical perspective, however, it never was. Similarly Tracy Emin pretended to be the spoilsport with her *My Bed* piece (1998), which got her nominated for the Turner prize in the first instance – and some £150,000 for the bed thereafter. The provocation to exhibit a bed with dirty linen, not a painting or sculpture, made her the spoilsport first and then London's art world's most cherished child. Tracy Emin's playful act consisted in leaving the magic circle and re-entering it at the same time.

There is of course a certain risk contained in the strategy applied by Emin and others. The risk consists of not being able to re-enter the circle one just left. Tracy Emin is clever enough to keep this risk very low. She does so by positioning clues to the art world and the art market. The bedlinen does not differ substantially from a painter's canvas and everyone familiar with the history of painting in the 20th century will immediately recover Claes Oldenburg's spoilsport masterpiece *Soft Bathtub—Ghost Version* (1966).

It is the way artists show their spoilsport activities, rather than the fact of not following the rules, that makes spoilsport strategies a driving force in the development of the arts. Other than Huizinga's (1955) assumption that

the spoilsport leaves the magic circle, there is a playful mode of trespassing the rules, that reinitiates the magic circle in the very same moment it seems to have broken into pieces.

INTERPASSIVITY
Interactivity is at the core of gameplay in any conceivable computer game. It seems impossible to imagine how gameplay would work if there was no interactivity between human and computer involved. But what happens if a gamer writes a script to enable his or her avatar to perform certain actions in the absence of the player? The game artist who lets the game engine go on its own and rejects his responsibility to control the avatars does not get entangled into the quest of loss or win, and he rejects the basic rule of any game, which is: You have to play! The spoilsport, however, does not leave the arena completely. He remains a voyeur, a spectator of an action he enjoys passively. In this regard the introduction of auto-executables, i.e. software agents physically detached from the players, and other modes of delegated play can be righteously called interpassive gaming. Pfaller and Žižek point out that the psychological aspect of interpassivity is grounded in our subjectivity. Pfaller and Žižek convincingly demonstrate how certain works of art seem to provide for their own reception. One cannot help feeling that these artworks enjoy themselves or that we enjoy through them (Van Oenen 2008). The mechanism described by Pfaller and Žižek can again be found in games and their modes of performance. It is not only in Game Art but in everyday gamers' practice where interpassive phenomena can be observed. Delegated enjoyment and delegated fear are possible forms of letting go in First Person Shooters. We know that it can be fun to just camp in an massively multiplayer online role-playing game (MMORPG) and watch others play through the eyes of an avatar. We have experienced delegated death fears when about to be shot and we know peer players who take some masochistic interpassive delight in being fragged. But even less martial areas of disguise and simulation like the SecondLife environment will disclose the interpassive delegation of love, lust and longing.

ARTISTIC INTERPASSIVITY: ZERO INTERFACES
Leif Rumbke's *Wargame* restricts interface action to a "Stop the Game" command only – implemented as a nuclear fire button's binary single function. The interface in striking red and impressive size limits the player's interactivity to one single non-reversible command. Conceptually related but

functionally inverse are game artists like Corrado Morgana's *CarnageHug* (2007). The game runs in auto-execution mode and does not allow for interactivity except for the minimal "Start" command. *CarnageHug* uses the Unreal Tournament 2004 game engine, to set up and run a bizarre, self-playing spectacle. Morgana removes the weapons from the level, leaving the player pawns passive and purposeless. He also has the player pawns attack each other with ever more powerful weaponry in a ridiculous massacre without player-based gameplay objectives or other constructive teleological human-player commitment. The game runs in a disinterested manner as far as winning and losing the game is concerned. If we are prepared to follow Kant's suggestion that disinterest will open the door to understanding the faculties of the observed object, interpassive works like Morgana's *CarnageHug* therefore qualify as works of art or at least focus our attention upon something outside the magic circle of normal gameplay.

Morgana is a spoilsport in the traditional sense of the word, because he denies us the simple pleasure of man-machine interaction and intentionally shrinks the potential of the interface usability down to degree zero. The interface is a "zero interface" that mocks interactivity. However, the piece does not make us completely leave the magic circle of the game. We take part in a reinterpretation of its. The tournament action as we know it is reterritorialized into the artistic arena. And almost at the same moment that we think of having left the magic circle of Unreal Tournament, we find ourselves caught in the magic circle of the game called art. We keep watching and we keep being caught.

Machinima, as the paradoxical attempt to watch gameplay without playing, is another popular non-sport where the spectator becomes spoilsport and traitor on the game's premises. Machinima puts the viewer into the voyeur's seat and keeps oscillating between cinema and game experience without fully committing to any of them. It is "meditative inaction" – as Christiane Paul rightly calls it – that ridicules interaction in games (Paul 2006: 28).

If we can enjoy the outsourcing of enjoyment, we have to either declare this as a perverse, a hysteric, and a neurotic attitude in a Lacanian perspective (Van Oenen 2008), or analyse it as a sophisticated spoilsport attitude of staying in the magic circle when pretending to leave it.

Ludic interfaces and zero interfaces are devices for artists to play the spoilsport in an environment where "fair play" means nothing else than playing by conventional rules.

REFERENCES

Barthes, R. (1953) *Le Degré zéro de l'écriture*. Le Seuil.

Fuchs, M. (2009) "Ilonpilaajia ja pelihaita: Spoilsports and Cardsharps," Playfulness Conference, Tampere, Finland.

Huizinga, J. (1955) *Homo Ludens. A study of the play element in culture*. Beacon Press.

Juul, J.(2005) *Half-Real: Video Games between Real Rules and Fictional Worlds*. MIT Press.

Kirriemuir, J. (2007) *The Second Life of UK Academics*. Ariadne.

Paul, C. (2006) "Mary Flanagan, [GiantJoystick]," in *Game/Play*. Furtherfield.org and Q Arts.

Pfaller, R. (200) *Interpassivität. Studien über delegiertes Geniessen*. Springer Verlag.

Pfaller, R. (2008) "Interpassive Persona." Unpublished conference paper for amber08: Interpassive Persona Conference, Istanbul.

Salen, K. and Zimmermann, E. (2004) *Rules of Play: Game Design Fundamentals*. MIT Press.

Trevor, T. "Robot-Me: Affective Machines and Object Relations." http://www.supertoy.org/cgi-bin/wiki/read.cgi?section=Supertoys&page=robot me, last accessed 20/11/09.

Van Oenen, G. (2008) "Interpassivity revisited: A critical and historical reappraisal of interpassive phenomena." International Journal of Zizek Studies.

GAMES

The Legible City (1999) by Jeffrey Shaw

[GiantJoystick] (2006) by Mary Flanagan

Wargame (2005) by Lief Rumbke

The center of the universe has infinite paths of approach (2007) by Jess Kilby

CarnageHug (2007) by Corrado Morgana

RSG's Kriegspeil,
an interview with Alex Galloway
Marc Garrett

In October 2009 Furtherfield.org's HTTP Gallery,[1] hosted the *Game of War* Weekend by the Class Wargames[2] group based in London, which involved a weekend of game playing and game making and also featured the premier of their film *The Game of War*.[3]

The *Game of War* is a Napoleonic-era military strategy board game. Guy Debord, strategist of the Situationist International, developed it with Alice Becker-Ho while they were in exile after the May '68 revolution. Alongside this weekend event at HTTP we were offering for sale the *Game of War* box set by Alice Becker-Ho and Guy Debord.[4] It includes the board game and pieces (made from thick cardboard) along with a book of instructions, rules, and a move-by-move analysis of a game played by Becker-Ho and Debord.

Debord came to regard *The Game of War* as his most important project.

> "So I have studied the logic of war. Indeed I succeded long ago in representing its essential movements on a rather simple game-board... I played this game, and in the often difficult conduct of my life drew a few lessons from it — setting rules for my life, and abiding by them. The surprises vouchsafed by this Kriegspiel of mine seem endless; I rather fear it may turn out to be the only one of my works to which people will venture to accord any value. As to whether I have made good use of its lessons, I shall leave that for others to judge."
> (Debord 2004: 55-56)

The Situationist International (S.I.) was made up of of artists, anarchists, Marxists, cultural revolutionaries, modernists critical theorists and other undefineable groups. Freeing it from the clutches of a hermetically sealed, gallery based system, they devised strategies to bring art and the

1 Class Wargames - Game of War Weekend at the HTTP Gallery.
http://www.http.uk.net/events/gameofwar/
2 http://www.classwargames.net
3 *The Game of War*, the video can be seen in five chapters: Terrain, Arsenals, Combat, Cavalry and Lines of Communication. Directed by Ilze Black; script writers Richard Barbrook and Fabian Tompsett; xenography by Alex Veness, voice over by Hayley Newman and Alex Veness. http://www.classwargames.net/pages/video.html
4 *The Game of War*, the video can be seen in five chapters: Terrain, Arsenals, Combat, Cavalry and Lines of Communication. Directed by Ilze Black; script writers Richard Barbrook and Fabian Tompsett; xenography by Alex Veness, voice over by Hayley Newman and Alex Veness. http://www.classwargames.net/pages/video.html

creativity of the artistic act into everyday life and to open creativity up for others from outside of the traditional realm of arts practice.

The Internet has given rise to an increase in activist art that adopts Situationist ideas and strategies. This work explores its own voice by defining alternative territories for creativity; challenging not only traditional approaches to politics, but also re-setting the boundaries of art. Many artists have attempted to bypass traditional avenues of art discourse, working with technology and incorporating networked functionality and consciousness in their work. They understand that mainstream culture is as much a part of their medium as are the digital media and tools they use. Adding Situationist approaches to the mix gives rise to a critical artform that crosses and connects genres and practices that infiltrate various areas of the everyday.

Our own explorations, at HTTP Gallery, of art at the crossover with games culture have brought us closer to the realisation of a less contained and limiting, mono-cultural approach and definition of art.

This interview with Alex Galloway about the Radical Software Group's (RSG) version of *The Game of War*, *Kriegspiel*, took place alongside preparations for the *Game of War* Weekend events at HTTP Gallery. This got me thinking about the different approaches taken by the Class Wargames group and Alex Galloway, their relation to the ideas manifested in Debord's game, and its reworking in the physical world and for the Internet. Both approaches offer fruitful insights into the politics, psychology and strategic dimensions of Debord's original. They reconnect and re-introduce to us their own, perspectives on Debord's *The Game of War*.

I have known Alex Galloway for a long time now, but although we share a history in Net Art and Media Art culture we have only met once (briefly) in New York in 2002. A lot has changed since the mid-nineties when we were both first exploring the possibilities of networked art, creatively and critically. The interview you are about to read comes from a series of questions I sent to him by email. This interview is merely a beginning; a connection between us which promises to develop into further discussions in the near future.

MG | What attracted you to Guy Debord's *The Game of War*?

AG | To make a computer game from the work of one of the twentieth century's most notorious radicals – of course the opportunity was too tantalizing to pass up. This is the surface reason. But we very quickly

realized that the game was overflowing with theoretical and philosophical details that are quite provocative. (I say we because this game was created by a team of artists, designers, and programmers.) For example, why is this game so normal, so mundane, while Debord's other work is so radical? Why make a game about Napoleonic campaign warfare? Why not make it about rhizomatic drifts and distributed resistance? In short, why is there nothing "Situationist" about this game? We don't attempt to answer any of these questions in the game itself. Yet elsewhere in my own writings I present some arguments that begin to answer questions like these.

MG | Why create a rework, a contemporary version for the Internet in the form of *Kriegspeil*?

AG | At the first level it was entirely practical: when we started working on it, Debord's game was essentially unavailable to play, particularly outside of France. The games that had been sold commercially in the 1980s are very hard to find, and the game rules that had been circulating were still quite obscure and often contained translation errors. Then in 2006 an important book by Debord and his wife containing the game rules was reprinted in France, a book that had been out of print for some time and was quite rare (although I did access it on microfilm in the Bibliothèque nationale in Paris before later purchasing a copy second hand). On the heels of this reprint, the first English translation ever was released in 2008. This helped allow people to play the game, many for the first time. During this period a few different groups have started to play the game, most notably a group in Britain called Class Wargames who have recreated a physical facsimile of the game, and then eventually my group who released a computer-based version a few months later.

MG | Did you regard the making of *Kriegspiel* as an act of détournement in itself?

AG | Not at all. I'm not even sure if that is possible. A détournement of Debord is a kind of contradiction in terms. To attempt such an act would be at best to produce the most naive sort of echo, and at worst a defeatist accumulation of the avant-garde's energies. Our goal in making *Kriegspiel* was not to hijack Debord, but instead to recreate his "lost" game with as much fidelity as possible to the original, while still migrating the game in a

small way to the present context of computers and networks. This is why, for example, we changed the visual style of the game dramatically for our edition. We wanted the game to make sense in the context of contemporary computer games which is, relatively speaking, much more pop than the very modernist design of Debord's 1978 work. So I guess our primary goal had to do with historical research, and certainly nothing like a détournement.

MG | How is the warring experience within Debord's game of war different to that of other games, and how different is it to RSG's own version?

AG | We have mimicked Debord's combat mechanic as precisely as we know how, based on the written rules of the game that he provided. Thus, attack, defense, and movement all function in exactly the same way. That said, there are three large differences between the RSG version of the game and the table-top edition created by Debord in the 1970s. These differences are a consequence of having migrated the game to the computer. The first has to do with the lines of communication. In Debord's table-top game, the lines of communication were not actually displayed. The players had to project mentally the lines onto the board. In the computer version, we opted to draw the lines explicitly. It is reasonable to assume that Debord would not object to this change, as drawing the lines, for example using string, in the table-top version would have been awkward and impractical. The lines change often as pieces move around the board, and thus the lines must be regularly rejiggered. The computer automatically recalculates the locations of the lines and draws them explicitly. The second change has to do with movement. Following the conventions of computer games, we chose to add an assistive aspect which shows you all legal moves that a piece can make when you mouse over it. Again, this makes sense with the procedural rhetoric of computer games, but obviously was not available in the table-top edition. The third difference is perhaps the most significant one, since it has to do with the combat mechanic. Combat is rather complex in this game. It is nothing like chess, where one piece simply takes another piece. There is a non-trivial amount of arithmetic that has to happen during any combat encounter. Each side must sum up various attack coefficients to determine if a piece is killable. In Debord's game this was all done manually; yet now the computer calculates everything automatically. Some players have commented that this actually does change the experience of gameplay dramatically, to have all the combat numbers auto-calculated. I

think that's probably true. However we left this feature in the game because it improves game play dramatically, and in addition eliminates errors. Of course an argument can be made that Debord would not have objected to this "human element" remaining in the game. We leave it up to players to decide for themselves.

We have often joked that it would be useful to add a "Situationist Mode" to the game whereby the player can easily toggle these features on or off. In fact some of the preference settings allow you to do this already, if you wish to have a more so-called authentic experience of gameplay.

MG | Who has been playing *Kriegspiel* and what do you think it means for those who are playing it?

AG | All sorts of people have been drawn to the game, from people who are primarily interested in Debord and French radical politics, to people who are gamers and like the game simply because it's fun to play (for, it turns out, Debord was a good game designer). In my assessment, Debord created the game because it was a useful and fun way to learn about strategy, to experiment with strategic thinking. It did not, primarily, share the same kinds of aesthetic and political goals that one may find in his books and films. So in this way, the game is, as it were, politically "unaligned." I think this is one of the reasons why it appeals to all sorts of people, perhaps in a way not shared by Debord's other work.

Radical Software Group, http://r-s-g.org

REFERENCES

Debord, G. (2004) *Panegyric*. Translated by James Brook. London: Verso.

Debord, G. and Becker-Ho, A (2007). *A Game of War*. London: Atlas.

GAMES

Kreigspeil (2008) by RSG

Freedom of Movement Within Gamespace
Anne-Marie Schleiner

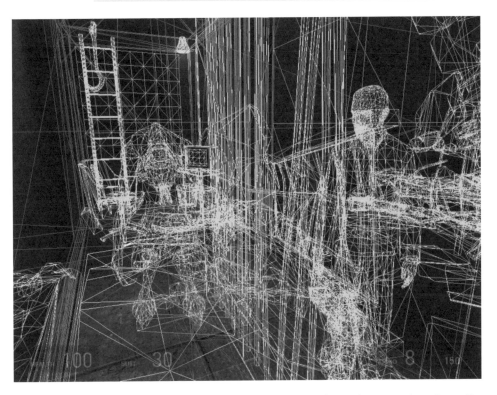

SYNOPSIS: As action game players search, navigate, and explore, the parameters of the game world solidify from a host of possibilities. Solitary movement within gamespace passes from the illusionary, through the virtual, to the pre-designed constraints of the actual, (within the bounds of made worlds). Escapist collaborative play loosens those ties binding the player to what is considered the Real. The artist may then transpose such ludic comportments to a variety of situations, game architectures and live city fluxes. Space and flows become playable.

Half-Life 2 snapshots by Luis Hernandez Galvan.

START MISSION: I trace a line following the player. The player moves in circles exploring the game world in all directions from a temporary start point.

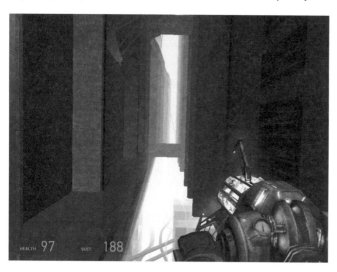

ZONE B: Finally an opening and breaking into the next zone. The player maps a zone of possibility once again, compelled to follow the flow of abandoned canals, lured by glimpses of distant cityscapes

Movement branches out from another node. Its trajectory responds to the limits imposed by walls and edges, insurmountable rusty piles of 21st century junk. Movement for the single player is running, jumping, exploration, bumping into walls and obstacles, momentary seduction by a vista, the collection of weapons and health, and intermittent adreneline boosts of conflict.

Action is searching, navigation, exploration, movement. The goal is discovery of this segment of the path itself. The player only vaguely remembers the overarching aim of the game narrative...

Circular loopings, what begin as multiple vectors of virtuality, eventually narrow into lines, into a singular solid channel of actuality. Sid Meier, designer of *Civilization*, describes a game as a collection of interesting choices. The player sorts though choices uncertain as to which ones are illusionary, dead-ends, or stepping stones to the next zone.

Meanwhile, the game architecture vibrates in a state of uncertainty. Giorgio Agamben's halo of possibility displaces the contours of the world along the edges. The halo zone is where possibility and reality, potentiality and actuality are indistinguishable.

GAME ARCHITECTURE: This vibrating limit, this threshold (Grenze) is the point of contact with Kant's Outside—the player cannot determine exactly where the world dissolves into the void

These worlds created by artifice are not limitless spaces of freedom.

Players and artists are "Being-free... 'thrown' into a definite range of possibilities" (Villa 1996: 126). Exploratory play is the freedom of disclosedness, an open comportment towards the game world. The will supercedes this freedom in everyday life. Mundane practicalities, errands, incrementation of MMO (Massively Multiplayer Online) game stats, and material demands have a tendency to circumvent and enclose.

LEVEL DESIGN: The giveness of the game world starts to solidify after the player bumps into enough walls. The hand of the overlord architect, of the level designer, becomes apparent. Interaction is a dialectic between potential and actual, but the potential is not limitless freedom. (Maietti 2009: 103).

ESCAPE: Light and irresponsible escapist play loosens the societal bonds entwining the subject, a subject free to become other selves. The ludic is dampened when the social meshes offline work, school and virtual worlds too tightly together. The social is understood as Hannah Arendt's everyday routines under the watchful eyes of family, State and Capital, (in her terms economy). For instance, social software Facebook's policy prohibits non-identifiable profile photos of game avatars. (Schleiner 2009).

An open ludic comportment to the world, on the other hand, teleports the ludic artist into unforseen situations. Customizing characters, modulating architecture, rearranging and diverting flows, the player remakes whatever she is given in a micro or macro way.

"In this regard, cheating is quite similar to the phenomenon of 'emergent gameplay', a term that refers to play strategies that have not been forseen by the designers." [As in the game *Deus Ex*, 2000] **(Kuecklich 2007: 119).**

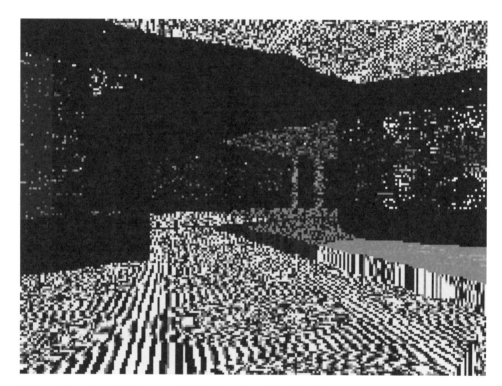

Epilepsy Virus Patch by Parangari Cutiri a.k.a. Anne-Marie Schleiner.

Playable architecture is transformable beyond the vision of ESP (Extra-sensory cheat perception through walls and hyper-awareness of opponents). Mods of games alter the virtual given. Invoking the Situationists, "The architecture of tomorrow will be a means of modifying present conceptions of time and space" **(Ivain 1953).**

Some games allow the player to modify the architecture real-time while playing. The walls of *GLTron*, inspired by the 1980's arcarde game movie *Tron*, are redrawn every game from the exhaust trails of virtual motorbikes. The player wins by escaping their enclosing trajectories.

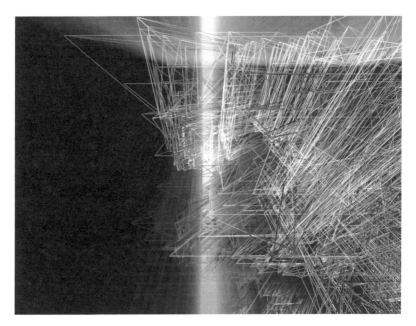

Oversaturation (2005) is a mod of GLTron by Mexico City based Luis Hernandez and collaborators. The game starts in a dark and empty gridded world. Over time a 3-D "city" of lines is drawn, suffocating the player and literally crashing his CPU while he attempts to break free from rampant urban overgrowth.

Conversely, *Katamari Damancy* (2004) gobbles up the game world, emptying it of its defining spatial characteristics, rolling up all furniture, landmarks and buildings into one giant sticky ball.

VERTIGO: Roger Callois' forgotten fourth category of play, games of vertigo, which he calls *Ilinx*, can be spotted as far back as 2-d side scroller Mario, through Prince of Persia, to the chasm of Quake 3, the planetary terrain of Halo, the rooftops of Mirror's Edge, resurfacing casually in the World of Goo. The player's being in the world reveals its own mortality as its defining potentiality of being. That is, until the player dies, hovers around as a ghost, regenerates, and is thrown *(Geworfen)* once again anew into a world of strangers and finite possibilities.

CONTINGENCY: If conditions are hospitable to ludic mutation, the player may cross worlds, into a live city of traffic and passersby, bicycles and skate boards, police and variable weather.

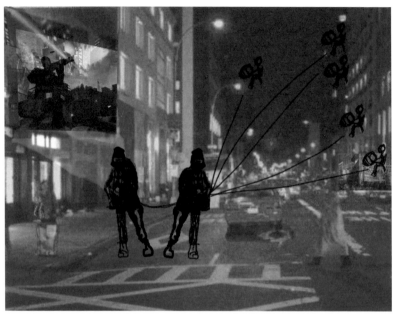

Concept sketch for *Out*, Live Urban Game Convention, Republican National Convention, NYC, 2004.

The heterogeneous game world of the actual live city is pierced by over-lapping vortexes of virtuality and augmentation. Observing the tendencies of night, day, weekday and weekend, the Situationist artist/game designer projects potential trajectories of movement and temporal flows. She identifies potential system hacks, points of intervention, modulation and encounter.

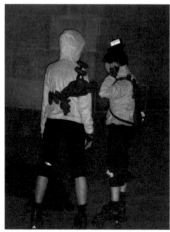

Riot Gear for *Rollartista*, Anne-Marie Schleiner and Talice Lee, Castellon, Manchester, 2006-07.

An artist's ludic comportment toward gamespace can solidify a given, unravel questionable goals or divert a flow. The vibrating limits of worlds are waiting to be discovered and played.

Suicide Solution,
Brody Condon,
2004

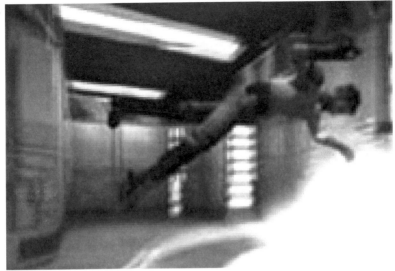

REFERENCES

Kücklich, J. (2007) "Wallhacks and Aimbots: How Cheating Changes the Perception of Gamespace." In *Space Time Play: Space time play: computer games, architecture and urbanism: the next level.* Edited by Friedrich von Borries, Steffan P. Walz and Matthias Böttger. Berlin: Springer.

Ivain, G. (1953). "Formulary for a New Urbanism." *Internationale Situationniste* 1.

Maietti, M. (2009) "Player in Fabula. Ethics of Interaction as Semiotic Negotiation Between Authorship and Readership." In *Computer Games as a Sociocultural Phenomenon: Games Without Frontiers - War Without Tears.* Edited by Andreas Jahn-Sudmann and Ralf Stockmann. Basingstoke: Palgrave Macmillan.

Schleiner, A. M. (2009) "Lightness of Digital Doll Play."

Villa, D. (1996) *Arendt and Heidegger: The Fate of the Political.* Princeton: Princeton University Press.

GAMES

Deus Ex by Ion Storm, Inc., 2000

GLtron by Andreas Umbach, 2003

Half-Life 2 by Valve Corporation, 2004

Oversaturation by Luis Hernandez, 2005

Everyday Hacks: Why Cheating Matters
David Surman

Did you know that *Sonic the Hedgehog 2* has sold 6 million copies worldwide as of 2006? It's impressive that a game made in 1992 would continue to sell over ten years later; most videogames enjoy retail success in the fortnight honeymoon after launch. While classic film and music are expected to sell and sell, games must make the most of a precarious and limited shelf life. Maybe, because we only play most of our games once, and finish even fewer, the rationale for committing long term retail space to classic games isn't there. Perhaps it's true, they *literally* don't make them like they used to; relatively cheaply, and for a dedicated consumer base. *Sonic the Hedgehog* (1991) had established a huge fan-following for the SEGA franchise, and its sequel raised the bar in all areas of design, quite different from the cynical contemporary cash-ins and third-party licensing that now dog the career of SEGA's erstwhile mascot.

Imagine games before Second Life, Facebook, Twitter and Chinese gold-farming. If we quantum leap back to 1992, it isn't an exaggeration to suggest that games culture was radically different. Of course, games consoles weren't as powerful as they are now, but in 1992 games culture was different for the simple reason that the Internet hadn't yet arrived in everyday culture. Nothing had yet connected, extended, thinned and overexposed games culture in all areas. Games culture was dense, idiosyncratic, lo-res, and *ours*, but chances are, with 6 million units sold, that it was everyone else's too. Games had arrived in people's homes, but games culture (the knot of today's chain-retail for videogames, TV and print campaigns, and communities) weren't joining up the essential pervasiveness of gaming. Gamers were everywhere, just not so connected up.

The marketing of "retro" as the preserve of the hardcore and the initiated geeks glosses over the widespread popularity of games consoles circa 1990. One of the easy marketing wins of each generation of consoles is claimed when the previous generation is cast and re-presented as being subcultural, niche and tailored to a dedicated audience by developers and publishers. Each future generation defines itself against the entrenched values of the former. As such we look at games culture as though through a distorting lens, believing positive changes to be much more recent than they actually are. These factors make well researched and written gaming histories a must for future generations.

In short, videogames have always been popular: it's the way gamers have been connected that has consistently changed, sometimes radically. And because of the ways in which gamers connect and relate to one another,

games design has had to reflect the values infusing each of these changes.

As an example, let's think about cheating, and ask the question – why does cheating matter? Do you know the "level select" cheat for *Sonic the Hedgehog*? Press up, down, left, right, then hold button A and press Start, all during the title sequence. Maybe it's presumptuous of me to think it, but if you were a gamer, you would be the kind of person who owned the SEGA console and a copy of Sonic, you'd have played it avidly, and crucially, known the cheat code. A big part of games culture is evidencing, to the friends wearing a steady butt-mark into your living room carpet, that you had new games, could play new games, and could hold your own in the knowledge economy of *cheating*.

In the period since the advent of the internet, it has become very clear that games culture is significantly shaped by the cultural capital "knowing about games" generates between individuals and groups. An incredible global infrastructure of websites, forums, blogs and other formats have proliferated in the chatter of newly connected gamer cultures. The cheat code anticipated this desire for conversation, and many (perhaps most) of the gaming magazines of the 1990s contained a centrefold spread, pull out section, or letters page that captured the collaborative input of gamers, rather than "expert" journalist or developer sourced codes. Through cheats, players vied for an opportunity to penetrate through the surface of the gameworld, to claim leadership and advantage, and wrestle control of the game from the orthodoxies of standard play.

Here in the UK, magazine-format shows like *Gamesmaster* (1992 – 1998), which provided information about games culture, also went to great lengths to present to audiences the importance and centrality of the cheat code. Cheat as hot topic, event, hack. Kids from around the country would "ask" the Gamesmaster (played by TV astronomer Patrick Moore) information about a certain problem, and he would deliver the goods, in nervy, quirky fashion. There is a connection between the popular culture of cheating in videogames and the way in which hacking (computer infiltration) has been broadly represented. Devices built for gaming consoles that enabled you to cheat, such as the Action Replay technologies developed by Datel, were carefully marketed to promote their capacity to "hack" in the vein of science fiction imagery, relating ideas of cyberspace and virtual worlds.

The player using the cheat code or device such as an Action Replay (which are still in production to date for contemporary consoles) doesn't

need to have any advanced knowledge of computer language or electronics to achieve their goal of "cheating"; the intervention they make is anticipated by the maker of the played game. As such cheating is bound up with the range of services or functions a game provides already. The way in which cheats feel as though they function "outside" or on top of the game, originates from the primary sense players have for "normal play" – play free from manipulation.

While the hacker needs to possess advanced knowledge of the operational world of computing, the cheater need only relate a commercially available code to the relevant game. Cheating could be considered a kind of "soft programming" in that it doesn't penetrate the code of the game at a fundamental level and replace it. Rather, it functions as an expression of what is already deliberately put there, or as an emergent effect of intentionally written elements.

Throughout the 1980s and 1990s hacking was represented in many different ways in popular culture. Movies such as *Sneakers* (1992) *Lawnmower Man* (1992) *Hackers* (1995) *The Net* (1995) created a veneer of cool around the activity of hacking, forever connecting teenage resistance and computer culture together. The stories and imagery of games changed throughout the 80s and 90s to reflect these cyberpunk roots as they grew increasingly mainstream. The stock function of saving at computer terminals, instant messaging and player status drew out of the rich imagery of William Gibson and Neal Stephenson, sequenced through Hollywood heroics and comic book skeins. Just as the "crucial hack" acts as the denouement to the cyber-thrillers of film, literature and TV, the cheat in game creates a sudden shift of power and perspective.

In *Sonic* and its sequel, you could cheat to select level. You could also, by adding a C button press, expand the level select to enter into a "debug mode". From there, you could press the B button in play and transform into a cycle of game assets connected to that level. With the press of the C button you could put those assets into the environment. In the top left hand corner, the score changes to reflect your XY positional coordinates within the level space. By turning from the eponymous Hedgehog into an asset, you could whizz around the level at heightened speed, taking yourself out of the action and dynamically changing your relationship to the level and game.

Suddenly, the story of Sonic unfurls and the design and fabrication of the space is revealed. You can put assets into the world, more and more enemies, extra platforms, rings and switches. This sort of cheat activity

highlights the elegance with which the original level is made. It also gives you obvious play advantages, in the form of rings and translocation. Cheating of this kind, and perhaps cheating generally, shifts our attention to the make-up of the game design, because it unbalances and distorts the standard experience.

Getting "behind the screen" to access the design underpins the common allegory of most hacker narratives. The *Matrix* trilogy and its associated media provides one of the most popular connections between gaming and hacking, and suggests that being a good gamer should facilitate the desire to look through the smoky mirror of effects to the mechanisms underneath. One of the tag-lines for Datel's Action Replay devices is "You've Bought the Game ... Now Play Like a Pro!" Are they alluding to the "pro" being a professional player, or game designer? In either case, cheating is represented as a means to get serious, step up and progress. The choice, of whether to cheat or not, is mirrored in the primary decision at the core of the *Matrix* movie – red pill or blue? One restores the balanced illusion; the other permanently breaks through to the chaotic machine.

Cheating is hacking for the masses. It is one of many opportunities to "soft programme" our technologies and culture without heavy reliance on advanced knowledge. Cheating creates an opportunity to play with design, think about it, and tinker around. By effectively unbalancing a game, we can move behind the screen to consider games through their limits. If you put too many assets on screen with the *Sonic* debug mode, the system would freeze and crash. In this it taught young players an important truth about games; that they aren't infinite systems, but rather careful gestures reliant on an economy of elements. Cheats of the kind seen in *Sonic* fostered a generation of gamers to be both critical and respectful of what games are. Knowing that the level is one configuration among many comes from a point of view only afforded through cheating.

Nowadays the net and its community, and the evolution of this perspective in games design, has given people more of a sense of what games are, and players will always cheat for the sake of advantage. Tacitly, through offering the means to cheat, designers open up new ways of thinking about games design, fostering an appreciation of their craft.

GAMES
Sonic the Hedgehog (1991) by Sonic Team
Sonic the Hedgehog 2 (1992) by Sonic Team

Playing with the Gothic:
If you go down to the woods tonight...
Emma Westecott

Artists working with games engage with the form in a number of ways; through intervention in the game system via modding, through recording the game engine for machinima and by building games with ulterior motives beyond "mere" entertainment. The range of artistic activity continues to hyper-spiral out as the borders between game developer and game player dissolve. The mainstream games industry is increasingly curious about the inclusion of the player in the ongoing evolution of their product; whether in Massively Multiplayer Online (MMO) service packs, console networks riffing social networking techniques or in the open provision of authoring tools. Game developers continue to move towards open inclusion of the player in the creative act of making games in addition to playing them. The hybrid offspring of gaming and the network run wild across the gallery space of the Internet. At the same time, 2009, despite the broader economic collapse, marks a certain critical mass of independent games development practice. What is the place and position of the game artist within this wider trend? As is often the case, the answer lies partly in the attitude and approach of the specific artists; much work in games art emerges from fan culture or from a desire to become part of the wider industry. When game art is conceived as contingent on political intentionality or cultural commentary, the field suddenly narrows. Another way to slice the art game pie is in the amount of game achieved in the work. Many artists reaching into this space satisfy themselves with working outside a game mechanic. Games remain insanely difficult to craft, full of technological distractions, and yet.

Tale of Tales (http://tale-of-tales.com) have been working with the game form for some time, but the 2009 release *The Path* (http://thepath-game.com/) marks their first commercially available single player game. With this game Auriea Harvey and Michaël Samyn create a modern gothic horror, a variation on the ancient tale of growing up, Little Red Riding Hood. This text looks to expose aspects of this evocative art game with the intention of celebrating a unique approach to digital games design.

It is relatively straightforward to see détournement at play in modding in the intervention in games engine and game media. The insertion of modder-created content within existent games is a fairly direct call to Situationist techniques, albeit requiring specific game literacy. Even machinima provides an approach for reuse of original works in a broader context. My focus in this article is in the area of videogame art that involves making games from scratch. This is interesting for a number of reasons, not least in that each game system necessarily expresses the intent of its

designer, thereby reflecting their own personal ideology; each engine is designed for a particular type of game experience. The deepest intervention is the one that has the ability to re-conceive the conventions of the form by engaging with the full process of game development from outside commercial pragmatics. *The Path* moves towards this in its conventional layering of game mechanic on top of game engine; the détournement can be seen in the game mechanic in its use and mis-use of existing gaming conventions. *The Path* re-conceives of games at a number of levels, from overall design conceit to visual approach through to specific control mechanics. Subversion from within the development cycle, close to the edge of mainstream commercial gaming remains a rarity. An argument could be made that projects like thatgamecompany's *Flower* scratches at the gaming experience by weighting the broader game aesthetic towards playful experimentation with themes from outside the gaming mainstream. Where else but in game form could you play the part of a petal whose task it is to re-animate a desiccated post-industrial deserted world? *Flower* offers a lyric gaming experience without offering a wider comment on game form as mass entertainment. Without this wink to game culture at large it remains a beautiful fragment.

The Path re-appropriates the timeless myth of Red Riding Hood for the gaming generation; in doing so it celebrates and plays with gothic themes of sex and horror within the spectacle of gaming. Although horror is far from a new theme for gaming, *The Path* encourages the player to stray and play against familiar urges for survival; each player character must engage with her Wolf in order for the game to progress, making her demise the win condition. The game does this at the same time as holding control back from the player. Control of the six sisters feels different due to the design peculiarities of each character; from Carmen's swinging hips to Ruby's slow limp. What is apt about re-telling this myth in game form is its play with the traditions of the Gothic, more specifically with the Female Gothic, a style of romantic literature that deals with the dark side of life in which the heroine leaves the known of childhood to venture into the unknown of adulthood. The myth of Red Riding Hood and its evolving form through history has been subject to multiple re-telling across media and is most popularly sourced to the 1697 Perrault version that offers a cautionary tale about promiscuity from which there is no salvation. From these moral roots Red Riding Hood grew to became a classic fairy tale, shape-shifting over time in response to specific cultural context. Recent work by authors

such as Catherine Orenstein (2002) have uncovered precursors to Perrault's version in which the girl escapes the beast through trickery. What remains interesting with this fairy tale is how this origin and newer variants feature a heroine triumphant without her prince, who succeeds in her "rite of passage" through her own cleverness without a happy-ever-after. This fairy tale has been oft reclaimed in modernity by feminists as a rite of power and contains strong visual motifs; the red cape and the wolf speak eternally of this essentially feminine tale.

The Path places this fairy tale in a game setting in which Robin, Rose, Ginger, Ruby, Carmen and Scarlet are doomed as the player must actively engage them with their wolf in order to move through the game; the player must kill them all to complete the game. It is not immediately clear, but each sister has her own experience, her own wolf. The character archetypes invoked in this mythic experience provide snapshots of the becoming of adolescence; from child to adult and girl to woman each sister represents a moment in time. The emphasis on each girl's death invokes memories of the necessarily lost stages of childhood over the inevitable passing of time. In a culture that romanticizes a hypothetical innocence of childhood, the inevitable sexualisation of puberty remains taboo and the question remains: how do we, as a society and as parents, support this hormone-charged need to create an independent adult identity. The memories triggered by The Path ring much truer to my recollection of the horror of my adolescence than the modern beauty myth that tortures girls today. Rather than assuming the scopic gaze of Laura Mulvey's (1975) film theory, moments spent playing The Path triggered my identification with almost forgotten memories of personal experience. This seemingly direct address resonates still. How better to consider this coming-of-age than by seeding game form with a play on eternal themes? The Path re-tells a tale of feminine becoming in a form that has, from time immemorial, passed on wisdom from generation to generation. The Path reminds us of the potential of gaming to let us see through another's eyes.

The game regularly takes control of the player character from the player, which although initially restrictive, soon re-codes control expectations to match the voyeuristic pace of play. Digital gaming always involves a screen, producing a doubling in which actions on a controller are represented back on screen; thus the player is always audience to her own play act. The Path's deliberate pacing holds the player at a distance from the action she triggers in a way that evokes a strong sense of voyeurism, leading to moments of dread and sensuality, emphasized by the haunting soundtrack,

while the symbolic forest beautifully shadowed with ethereal overlays builds rapt curiosity in the girl's hunt for her wolf. The lush treatment of game world, overlaid with translucent interface cues and atmospheric music, pulls the player into this sensuous gaming experience. In and of themselves the screen overlays are important as they provide clues for the player, from the direction of core game objects and environments, to clues to areas to visit with other sisters, to flash premonitions of future events, the interface blends with the moving action. This blending blurs and hides the standard game interface without restriction and for full visceral effect, the visual aesthetic softening the polygon edges through this approach, creating an almost period camera. The attention to detail in creation of an evocative world pays dividends given both the slow pace of play and the opportunity for multiple plays in the same environment.

Gaming remains a spectacular experience, appearing at odds with the Situationist project, yet is this really the case? Gaming has the potential to be subverted by the context for action that it provides. Indeed it is the action of gameplay that carries the seed for ongoing détournement and the creative refreshment that results. The direct reversal of *The Path* can be seen in its central mechanic, in the need for you to push the sisters to an almost certain doom, and in the seeming permanence of their death, at odds with the multiple deaths of game form. Through its provision of an auteur experience, *The Path* takes advantage of current trends in the broadening of games culture to new ways of making and playing games to deliver a strong and personal statement whilst showing that there will always be a demand to surrender to another's vision. By shifting the character context from Apollonian hero to Dionysian heroine, Tale of Tales set a fresh frame for gaming, one that points to the possibility for games that disturb and delight in equal measure.

REFERENCES

Mulvey, L. (1975). *Visual pleasure and narrative cinema.* In Screen 16, 3, 6-18.

Orenstein, C. (2002). *Little Red Riding Hood Uncloaked: Sex, Morality, and the Evolution of a Fairy Tale.* Basic Books: USA.

GAMES

Flower (2009) by thatgamecompany

The Path (2009) by Tale of Tales

Contributor biographies

Ruth Catlow

Ruth is an artist and educator. As co-founder of Furtherfield.org, a grass roots media arts organisation and online community and its gallery HTTP Gallery in North London, she works at the intersection of art, technology and social change with artists, hackers, curators, musicians, programmers, writers, activists and thinkers from around the world. She is currently developing Furtherfield.org's Media Art Ecologies programme.
http://www.furtherfield.org

Heather Corcoran

A curator/producer, specialist in media art and music, currently working as Curator at FACT (Foundation for Art and Creative Technology) in Liverpool. Recently she has worked at Space Media Arts in London and InterAccess Electronic Media Arts in Toronto, as well as producing a number of freelance projects. She works hands on with technology and technology communities – currently a Developer of the free software project Puredyne, the GNU/Linux distribution for media art. Received a BFA in New Media at Ryerson University in Toronto, and is an MBA candidate at Imperial College, London.
http://www.fact.co.uk

Daphne Dragona

Media arts curator and organiser, based in Athens. The last few years exhibitions and events have focused on the notion of play, its merging with art as a form of networking and resistance. Worked with Laboral Centro de Arte y Creacion Industrial (Spain) for the international exhibitions Gameworld and Homo Ludens Ludens and with Fournos Center for Digital Culture (Greece) for the International Art and Technology Festival, Medi@ terra. Currently working with ATA center in Lima Peru and the National Museum of Contemporary Art in Athens. PhD candidate in the Faculty of Communication & Media Studies of the University of Athens on social media. Member of the Media Arts Collective Personal Cinema.
http://ludicpyjamas.net/wp

Mary Flanagan

An artist, author, educator, and designer currently residing in Hanover, New Hampshire. Inaugural chair holder of the Sherman Fairchild Distinguished Professorship in Digital Humanites at Dartmouth College and the director of the Tiltfactor Lab, activist game design group. BA from the University of Wisconsin–Milwaukee, MFA and MA degrees from the University of Iowa, Central Saint Martins College of Art and Design, UK. Has exhibited internationally. Within the field of culture and technology, she is known for her theory of playculture.
http://www.maryflanagan.com

Mathias Fuchs

Artist, musican, and media critic, has pioneered in the field of artistic use of game engines in various game art installations. He started the first European Masters Programme in Creative Games at the School of Art & Design at the University of Salford in Greater Manchester. Creative Games is a discipline on the borderline of games, art and critical discourse. Has presented sound, media installations internationally.
http://creativegames.org.uk

Marc Garrett

Net artist, media artist, curator, writer, activist and musician. Emerging in the late 80's from the streets exploring creativity via agit-art tactics. In the early nineties was co-sysop (systems operator) with Heath Bunting for Cybercafe BBS. Co-director, co-founder, of net art collectives and communities- furtherfield.org, furthernoise.org, netbehaviour.org and other online platforms. Co-founder and co-curator/director of HTTP Gallery, London UK. Co-curating various contemporary Media Arts exhibitions, nationally and Internationally.
http://www.furtherfield.org

Corrado Morgana

Artist, musician (semi-retired) and curator. A doctoral candidate whose research project examines arts and videogames crossover practice, specifically transgressive and subversive production within existing game engines. Co-curated with HTTP/Furtherfield.org Game Art's programme; touring exhibitions, that explore game spectatorship, independent and experimental production. Been involved in various large scale collaborative projects, has produced video work, collaborative online projects and performed live electronica internationally. Dabbled in virtual reality research, has taught extensively about online practice. Has worked in a variety of digital guises from web developer to computer salesman to Games Design Lecturer. Most importantly he is an incorrigible gamer.
http://gamecritical.net

Anne-Marie Schleiner

Engaged in gaming and net culture as a writer, curator, artist and designer. Co-directed the anti-war game performance art initiatives Velvet-Strike and OUT. Taught at and participated in art residencies in Germany, Belgium, Spain and Mexico. Was an assistant professor at the University of Colorado, Boulder. Has shown her work internationally. Currently teaches game design at the National University of Singapore, Southeast Asia and is pursuing an international doctorate in ludic culture at the University of Amsterdam.
http://www.opensorcery.net

David Surman

Studied Animation at Newport before going on to gain a MA in Film and Television Studies at the University of Warwick. He is currently working on a PhD at Brunel University, examining concepts of style in the design and play of videogames. As a freelance illustrator and animator his work has been exhibited as part of individual and collective exhibitions in Italy, America and the United Kingdom. He has worked in a variety of promotion, design and direction roles for m80, Capcom, No-Fit-State Circus, European Live Arts Network and the National Youth Theatre. Programme Leader, Computer Games Design, Newport School of Art, Media and Design.
http://amd.newport.ac.uk/displayPage.aspx?object_id=4508&type=PAG

Emma Westecott

Worked in the game industry for over ten years, producing and programming games as well as lecturing in game design internationally. Achieved international recognition for working closely with Douglas Adams as producer for the best-selling CD-ROM adventure game, 'Starship Titanic' (1998, Simon & Schuster). Over the years, Westecott has built up a worldwide reputation for developing original, as well as popular projects and products. Has established herself as a figurehead and spokeswoman for a more emotional approach to gaming. Research Fellow, Computer Games Design, Newport School of Art, Media & Design.
http://amd.newport.ac.uk/displayPage.aspx?object_id=4510&type=PAG